This book is dedicated to my wife,

BECKY E. STEVENSON,

the wisest human being I know.

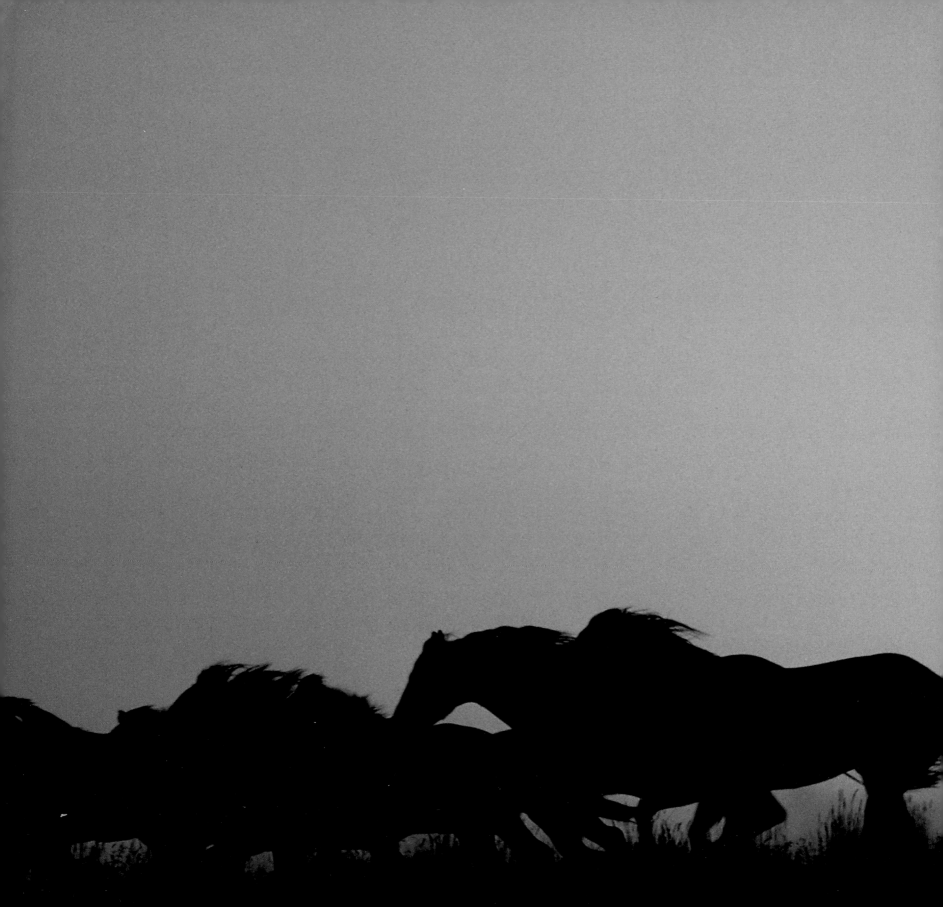

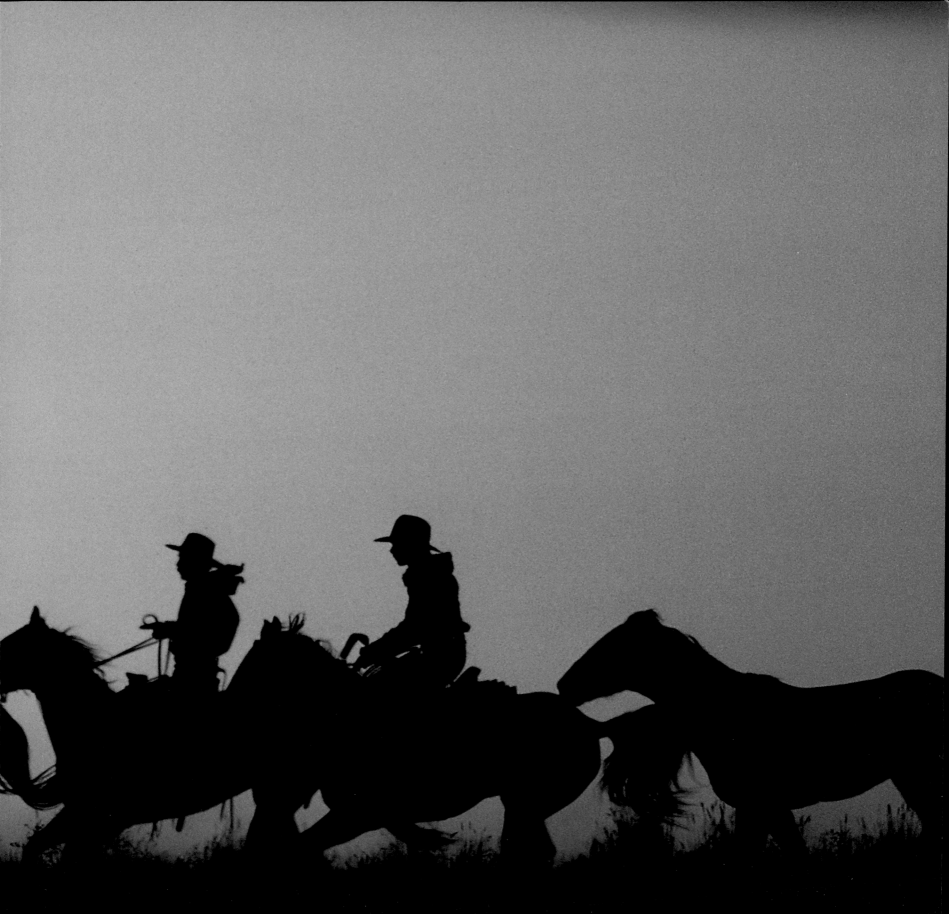

AUTHOR'S NOTE

I am not a cowboy. (And I do not play one on TV.)

Most people who know me would tell you that I am not very wise.

I have, however, had the extremely good fortune of spending many hours with real cowboys. Men and women who live their lives according to a simple code and a moral compass that has been passed down and tested over hundreds of years. (Yes, I said men and women. You see for me, being a "cowboy" is more about a state of mind, free from any classifications other than those that are defined by values and character—not gender or race. The term "cowgirl" pretty much says the same thing.)

Cowboy Wisdom is the result of observations from these men and women. Observations about life and how it should—or should not—be lived. Time-tested statements that serve as a guide to anyone, not just cowboys. And maybe that is the beauty of the concept of Cowboy Wisdom, the fact that there may just be a little bit of the cowboy in each of us. That part of us that wants to be judged by what we do, not who we are. That part that is true to our word, kind to animals, and generous to a fault. The part of us that wants to live a life that is simple, honest, and rewarding.

But as I stated, I am not an expert. In fact I cannot even claim most of these pearls of wisdom as my own. I am only the transcriber, if you will, the person who put them down on paper. But make no mistake, these statements are born out of experiences lived by real cowboys and cowgirls. My experiences have allowed me to capture some of this in the form of nuggets of wisdom. Many are funny. All ring true.

As one of the owners and creative director of an advertising agency that specializes in Western industry brands, I have been fortunate enough to spend a great deal of time with cowboys. People who ride. People who sing. People who sing about riding. And each time I am around them I find myself learning more and more about how life should be approached. Certainly many of these moments come on the heels of some poor soul's misfortune, the wisdom gained from what he <u>should</u> have done. But nonetheless, these are life lessons that are simple and meaningful.

This is by no means is a definitive book on Cowboy Wisdom. One could never write such a book because each day more and more wisdom is discovered and lived and experienced. Rather, this is just a small sampling of some of that wisdom. So, like my good cowboy friend Karl Stressman likes to say, "Let's get to the rat killin'."

DAVID STEVENSON

Chicago, Illinois

FOREWORD

David Stevenson is one of the funniest, most outlandish, most creative guys I have ever met. There is no limit to his energy—he reminds me of the Energizer Bunny®. We first met on a photo shoot for Wrangler Jeanswear. David was the creative director for the shoot and it took place on my ranch—the Bar Horseshoe in Mackay, Idaho. I was injured from a horse accident and hobbling around on crutches. The only things that kept me going were pain pills and laughter. David kept coming up with non-stop ideas and mischief. The entire crew of about 25 models, wranglers, stylists, producers, photo assistants, and of course, Robin Rich and Karl Stressman from Wrangler, were kept on their toes with David's antics.

Now, keep in mind that David is a city guy and all he really knows about the West is what he sees on photo shoots or reads in books or sees in movies. But he is a fast learner and he knows a good photograph and a real cowboy when he sees one. He put all of that together into a fantastic ad campaign, store promotions, and television commercials for Wrangler from the shoot. He later approached me to work on this book with him.

I had just finished a book about cowboy ethics with another city guy, James Owen, and it turned out to be a runaway best seller. In fact, I am a city guy myself, but moved out West 36 years ago, and I have published more than 30 books about the West. Maybe the city guys see the West through different eyes. I have spent the last 20 years preserving this part of American culture on film and concentrating on the thoughts and feelings of the real people of this region with my books, calendars, and prints. I thought this book about cowboy wisdom fit right in with this mission and the idea of the real West that I love so much. It relates directly to my friends and how they act and talk. The people of the West have great humor and a fun way of looking at themselves and the world around them. You can hear it in the music they play, the poetry and prose they write, in cartoons about the West, and even in the language at the local coffee shop.

I know there are a thousand more sayings, but David has done a wonderful job matching up my images with some of the best tidbits of cowboy wisdom for this book.

Keep the spirit of the West alive,

DAVID R. STOECKLEIN

Ketchum, Idaho

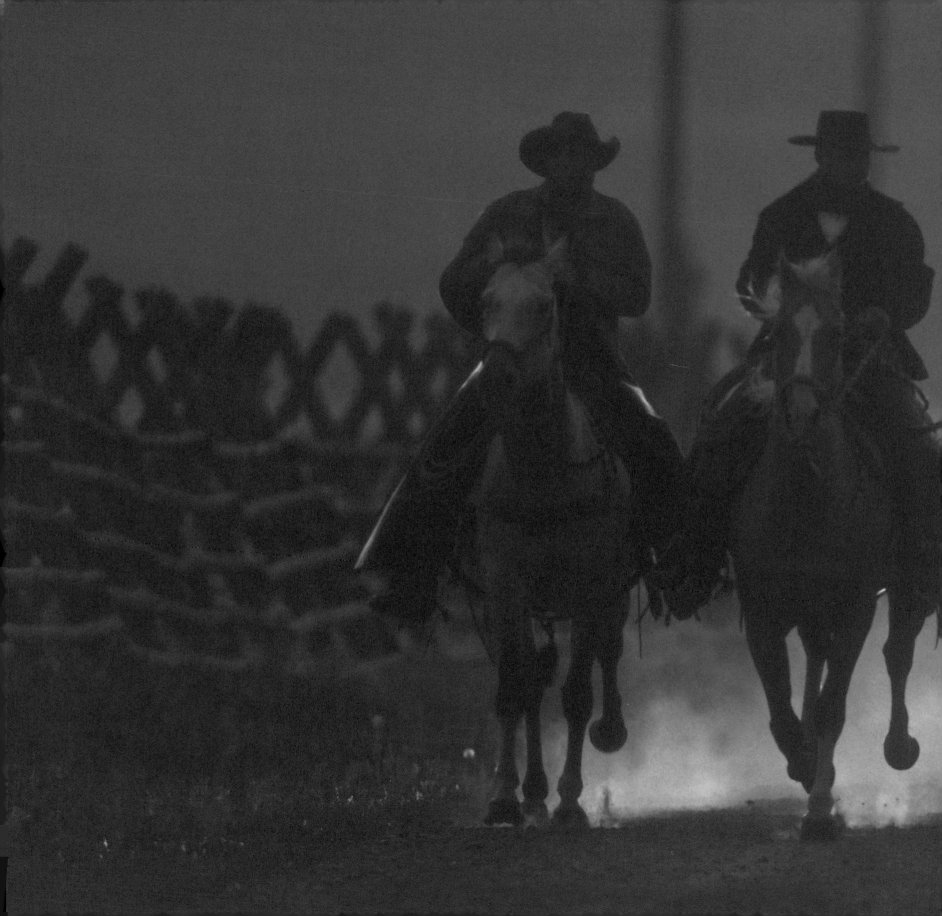

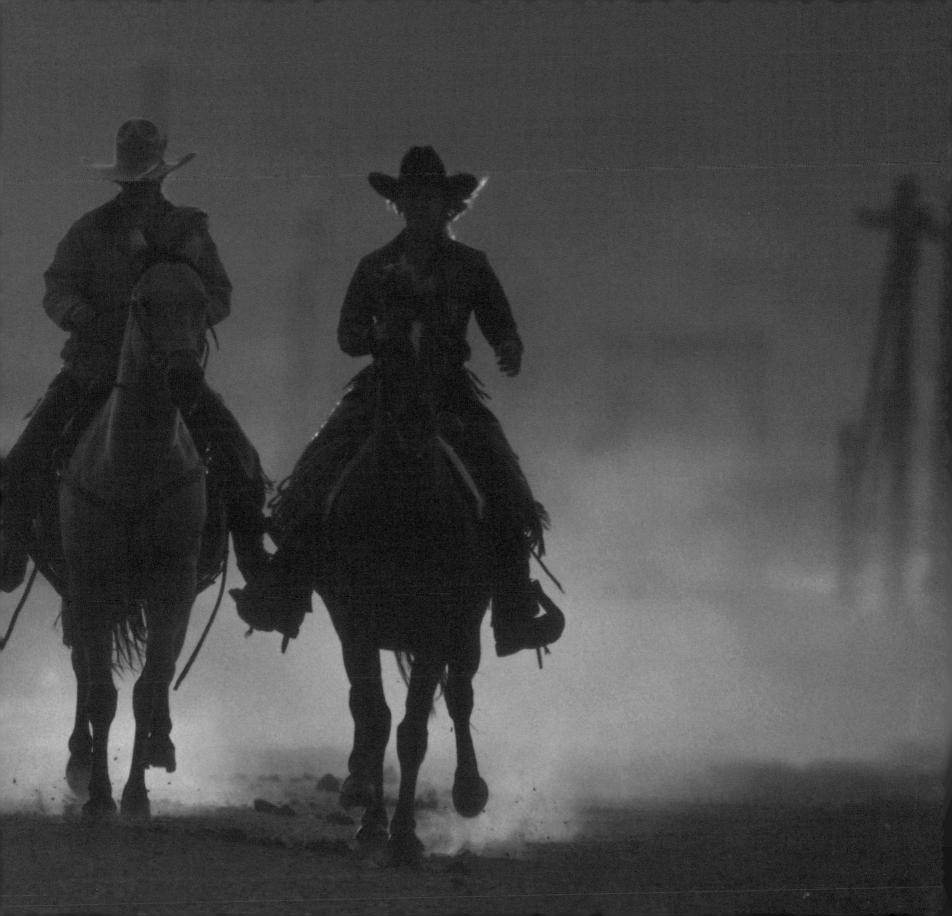

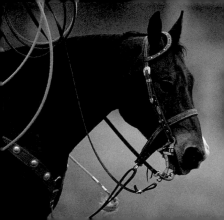

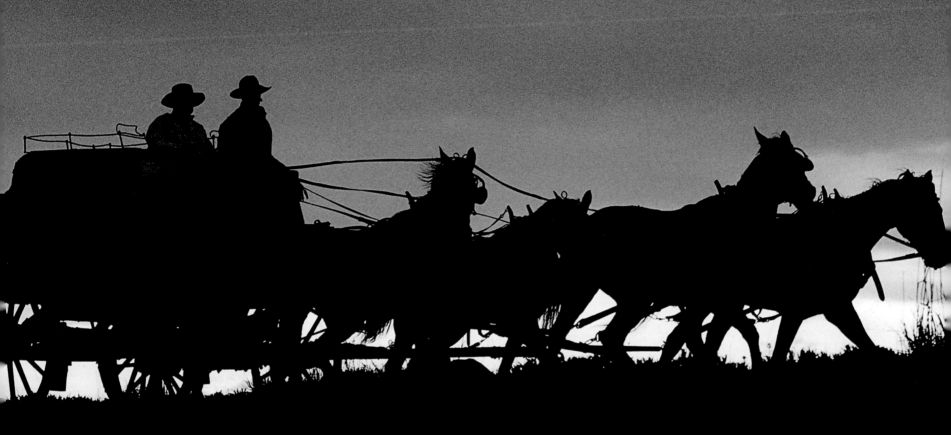

Menu

Cowboy Mug w/Coffee	$6.00
Coffee /1 styrofoam cup	1.00
Biscuits/Gravy	2.00
Biscuit/Beans	2.00
Cowboy Cobbler *Whip Cream*	3.00
Tri-Tip Lunch Plate (Salad, Beans, Roll, Tri-Tip)	8.00
BottleWater	1.00

Cowboy ChuckWagon Cooks
35664 Road 112, Visalia, CA 93291
559-627-0237

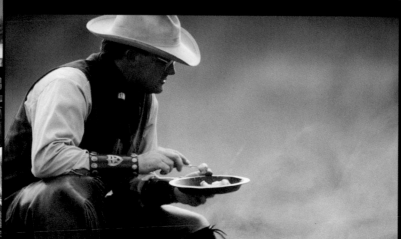

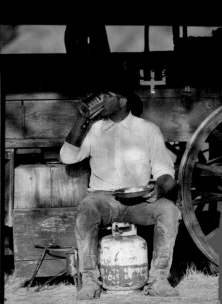

EVERY COWBOY GETS A NICKNAME.

JUST PRAY THAT IF THEY START CALLING YOU
"LIGHTNIN'",
IT'S BECAUSE YOUR HORSE IS FAST.

NOT BECAUSE YOU PEED ON THE ELECTRIC FENCE.

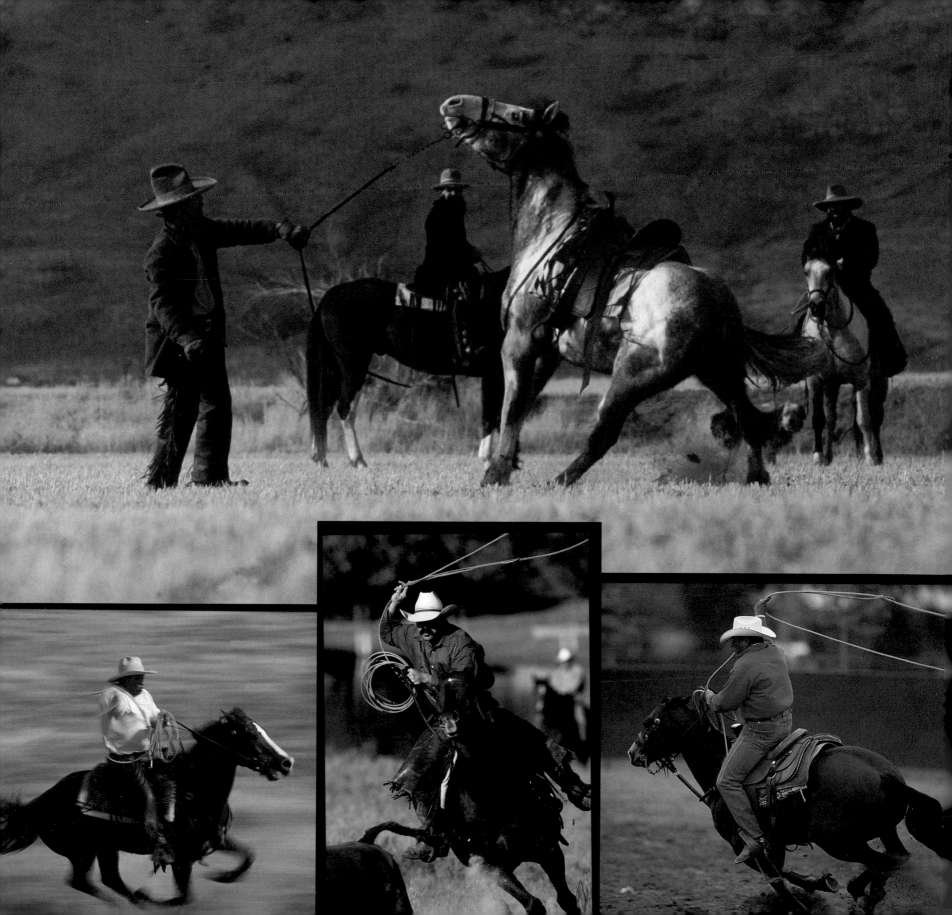

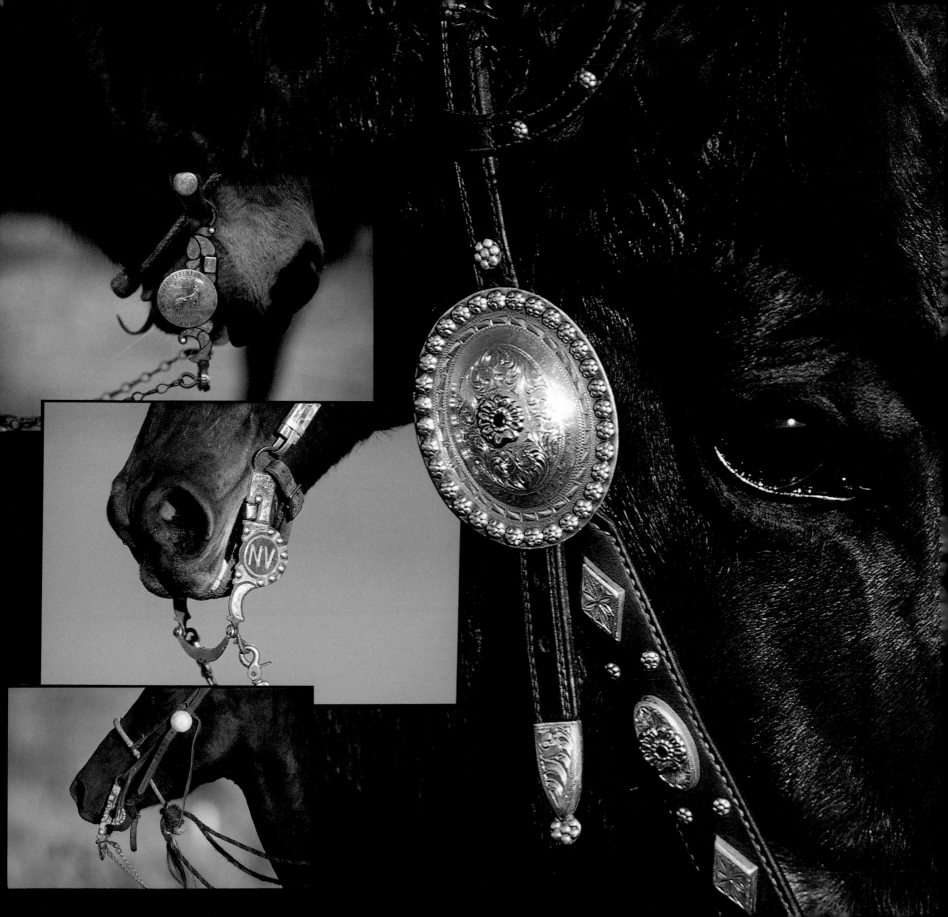

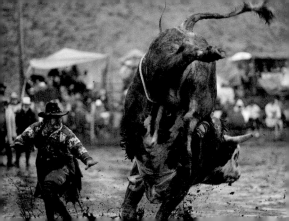

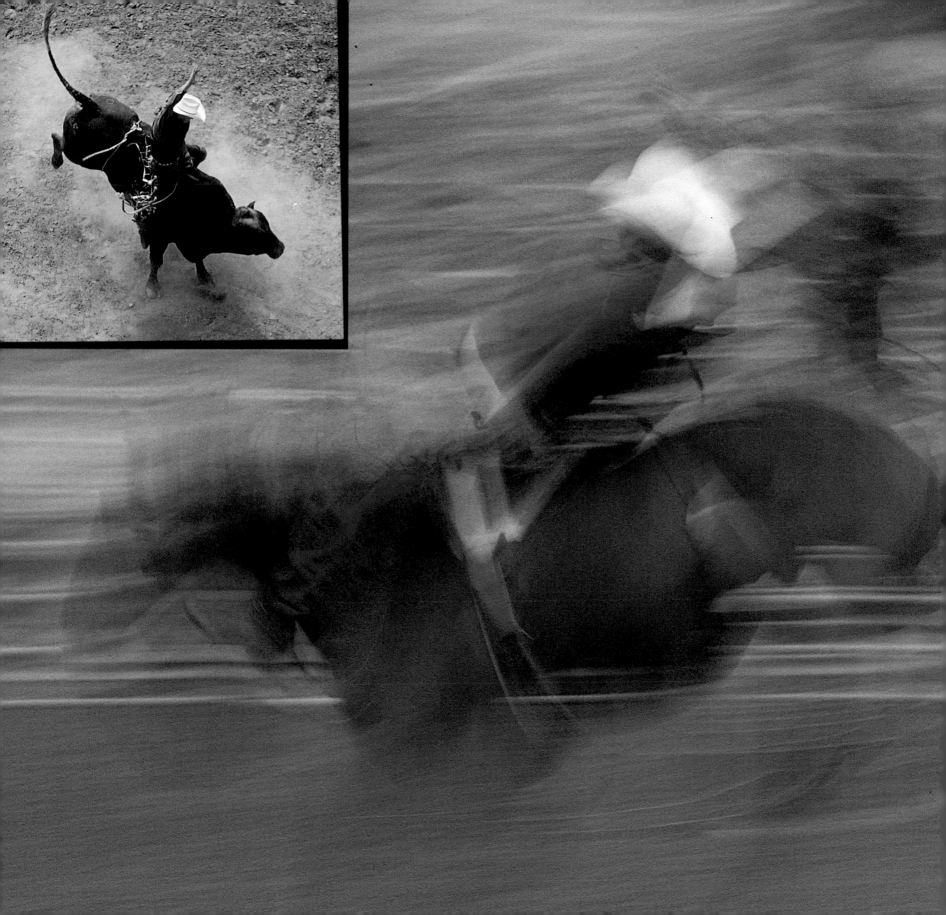

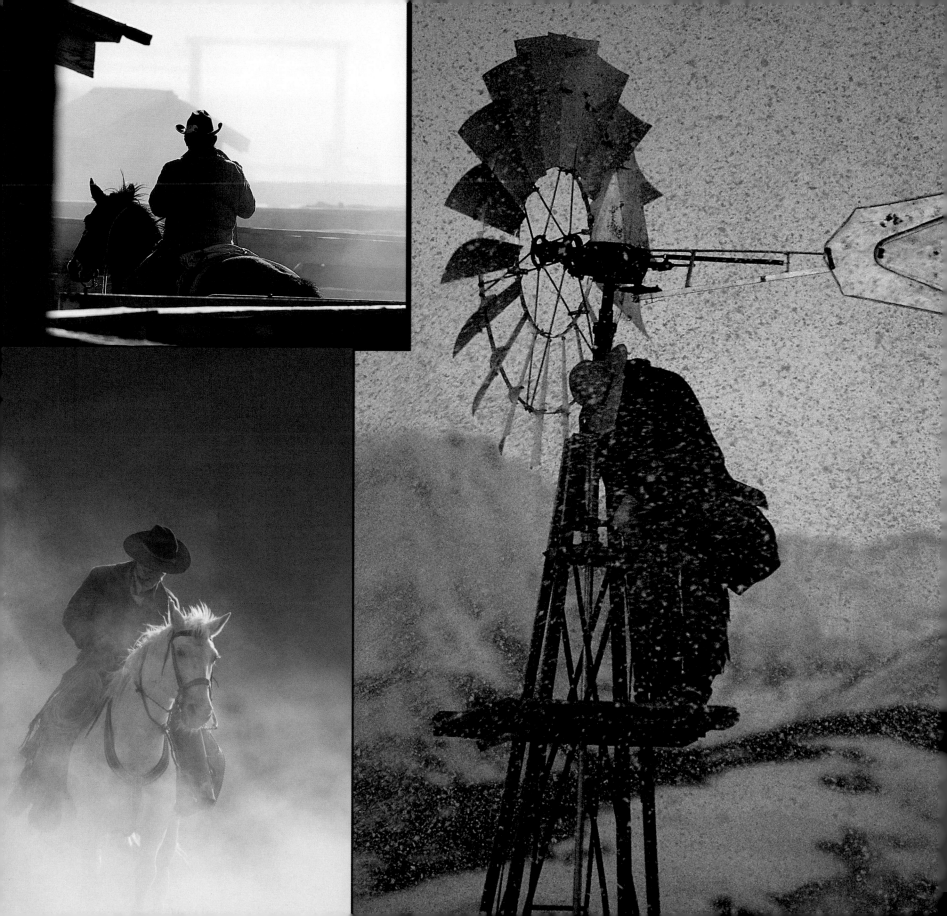

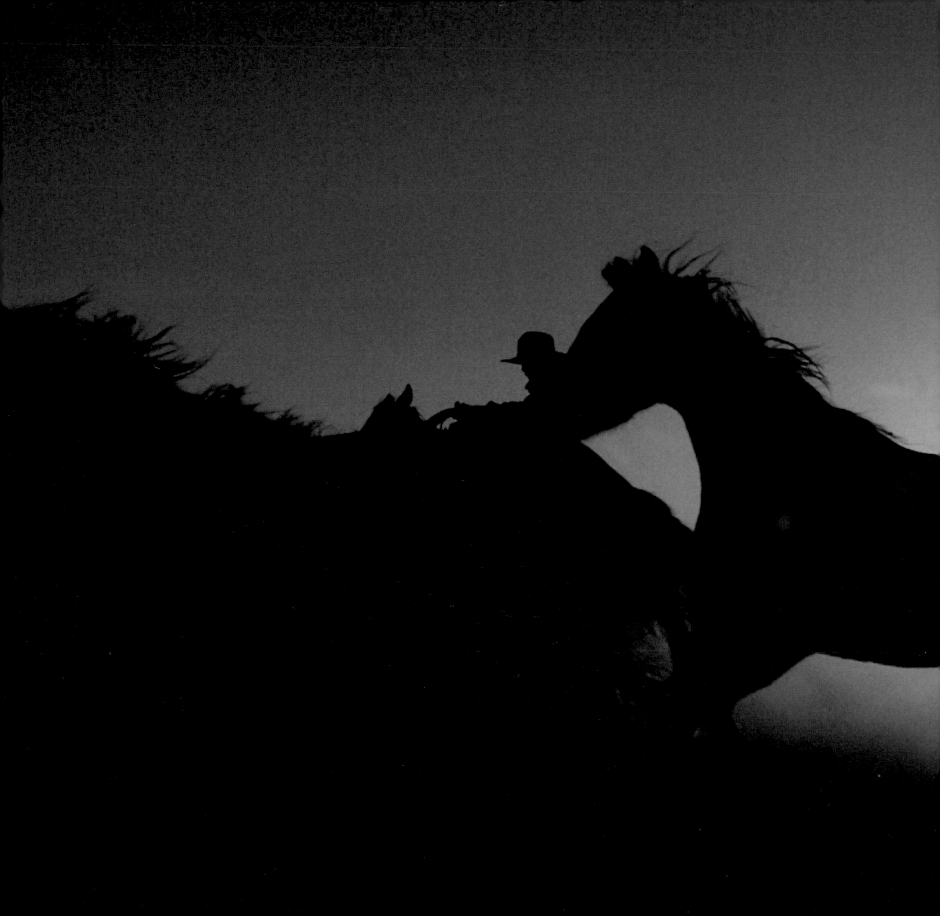

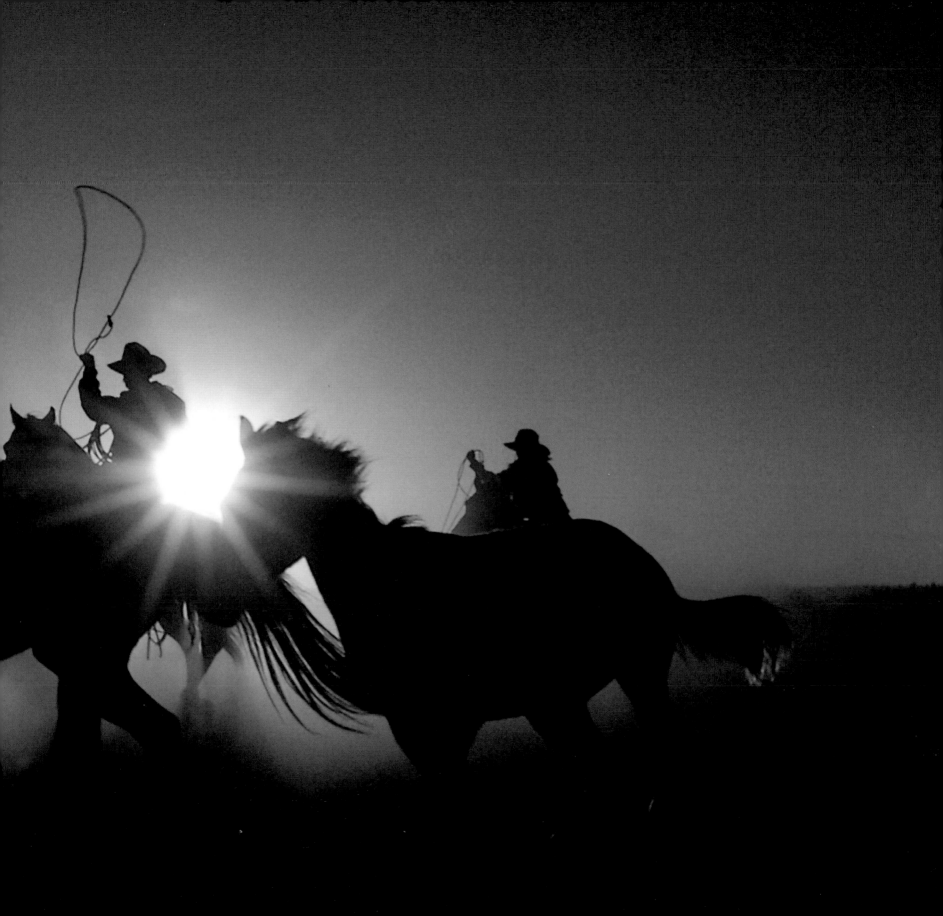

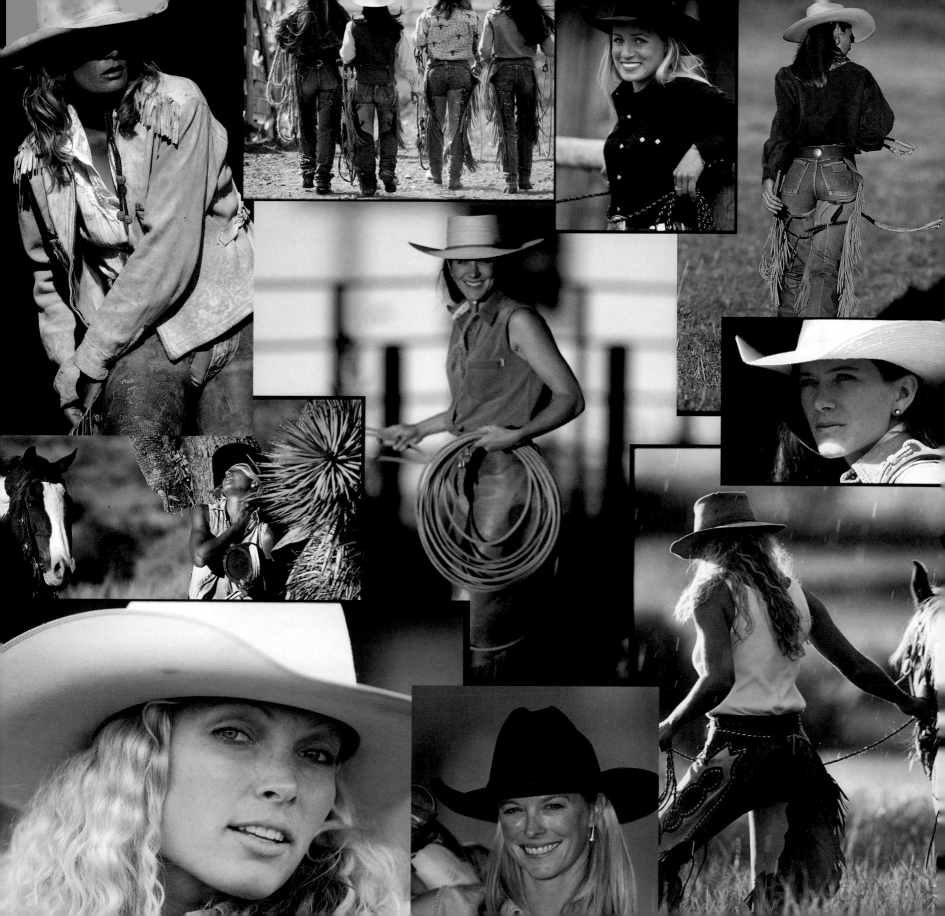

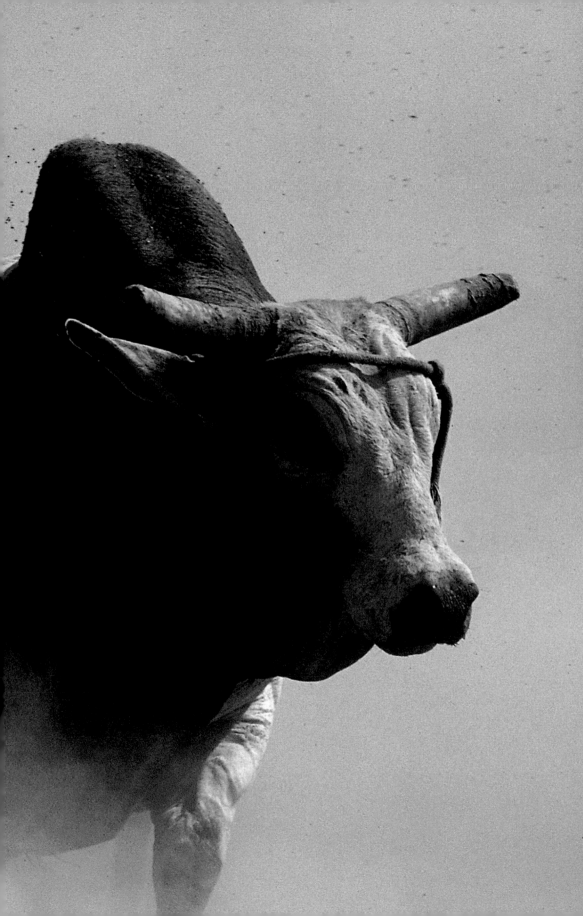

- WARNING -

Don't Cross This Field Unless
You Can Run It In 9.9 Seconds.
Our Bull Can Do It In 10 Flat.

Compliments of Early Dawn/Buckhorn Ranches
Oakdale, CA 209-847-8440

Cowboy Wisdom:

WHERE THERE'S SMOKE, THERE'S FIRE.

AND WHERE THERE'S FIRE,
THERE'S USUALLY STEAK.

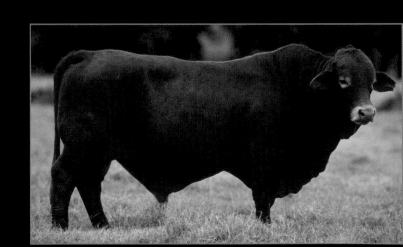

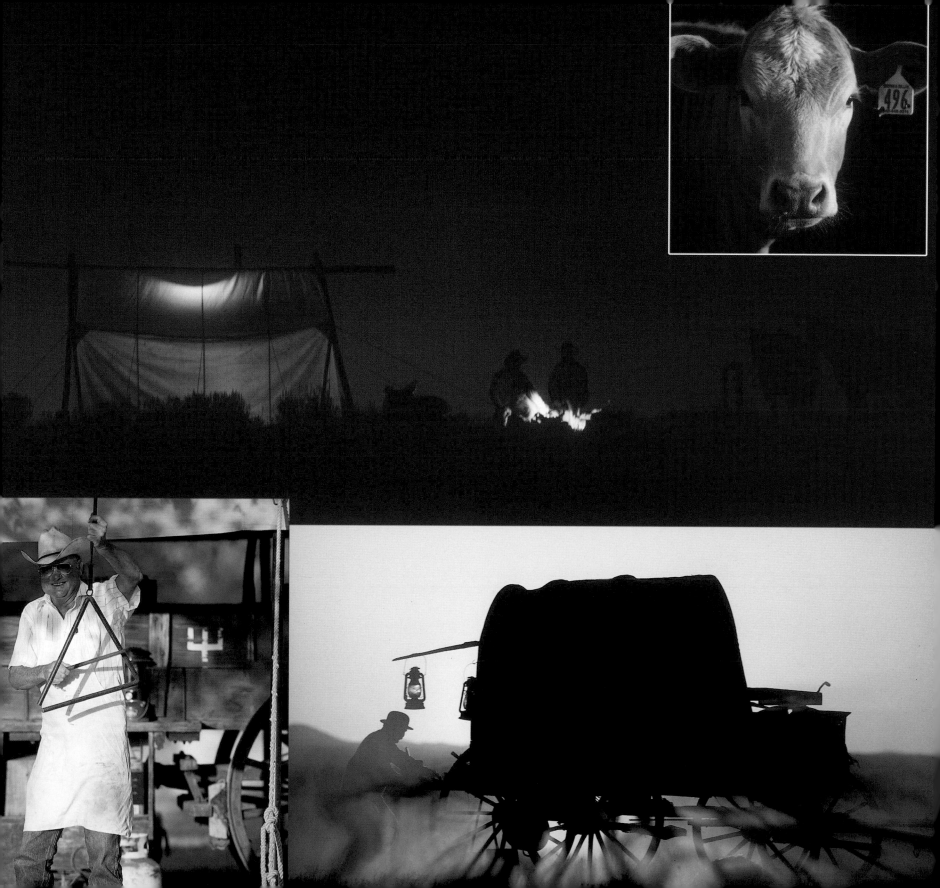

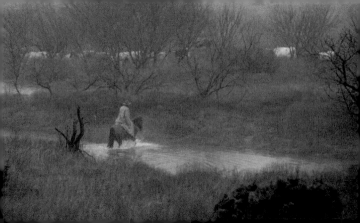

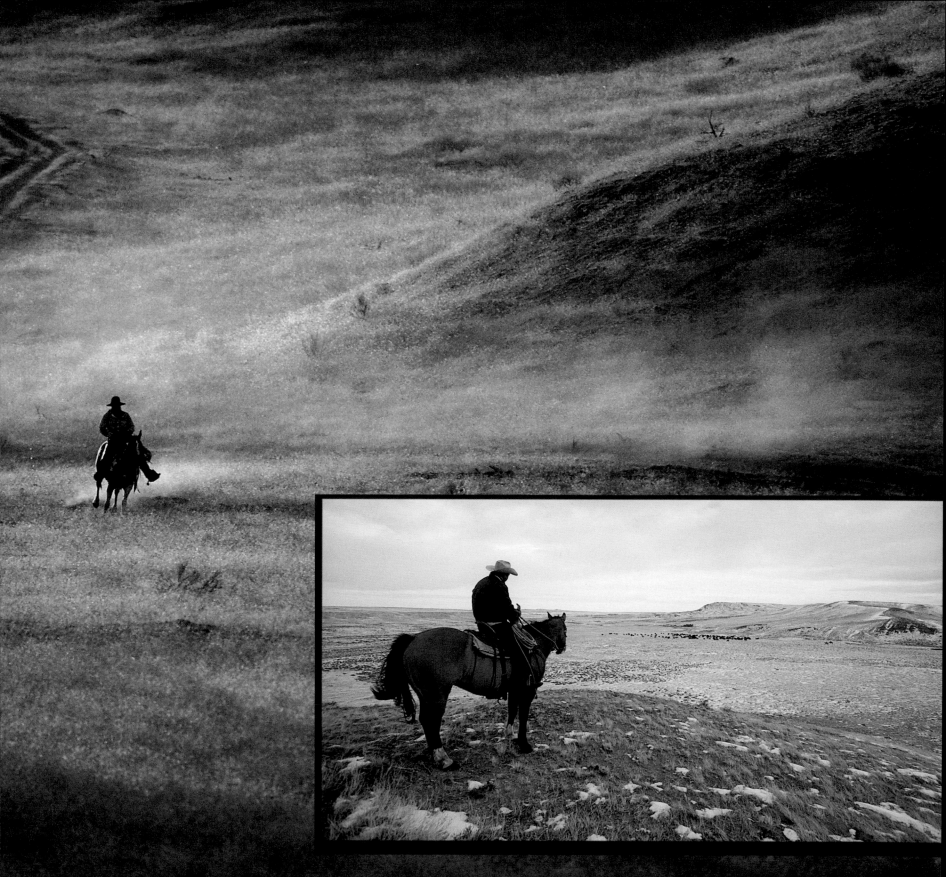

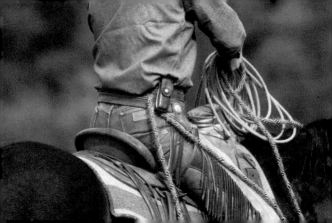

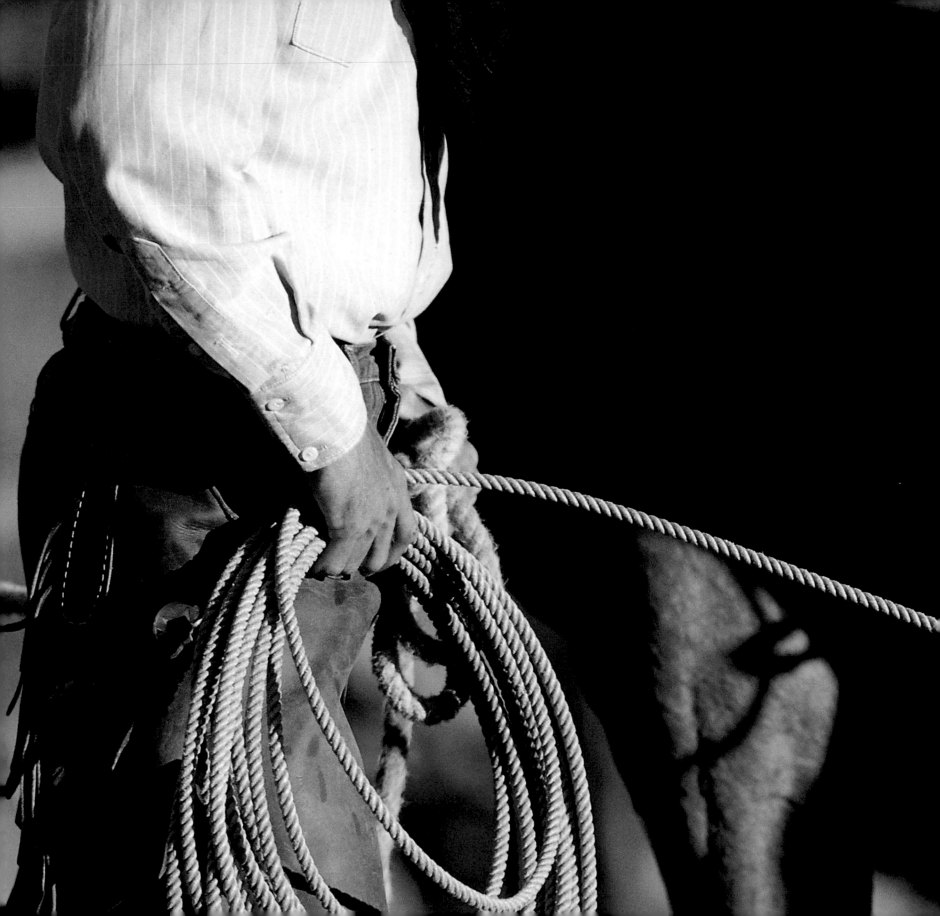

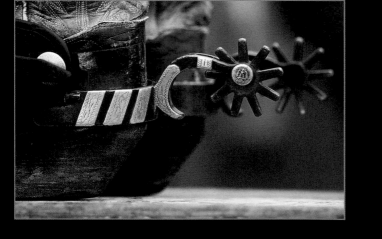

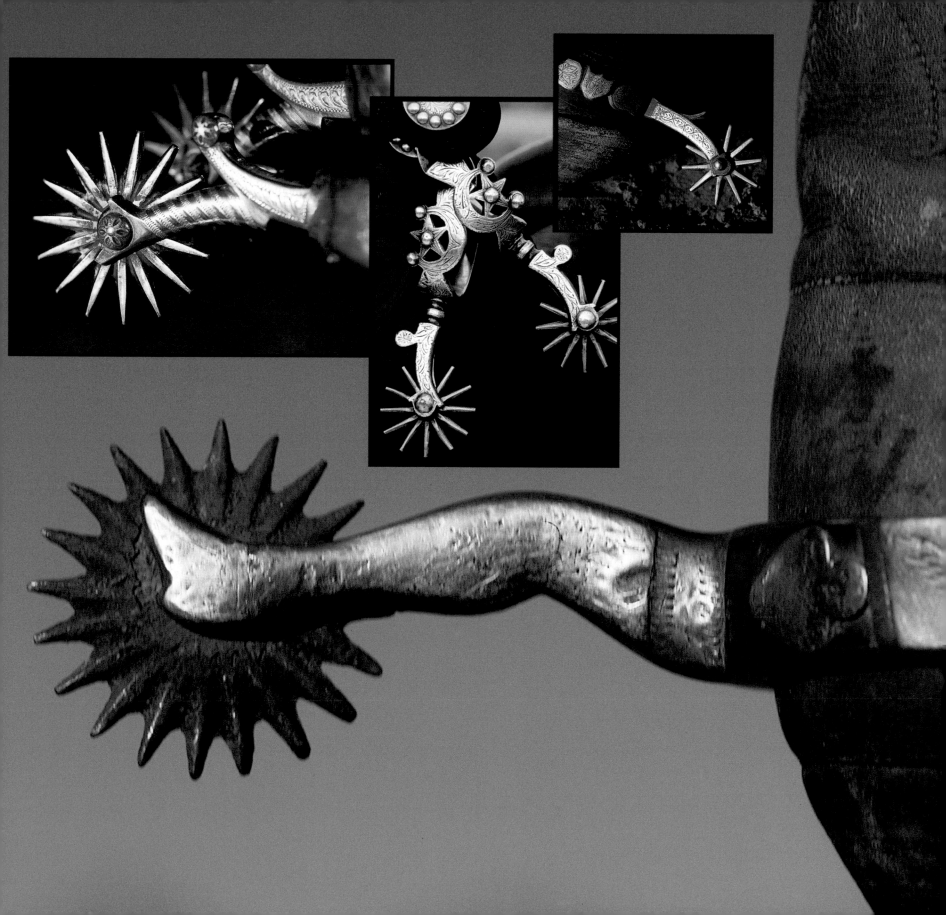

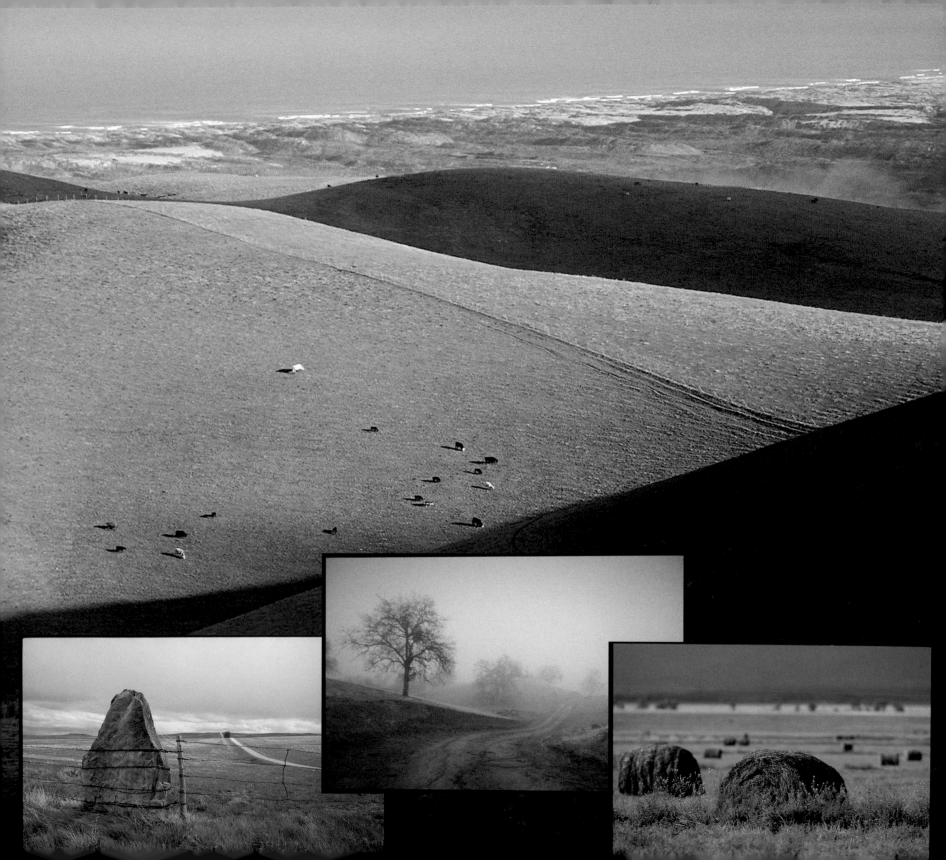

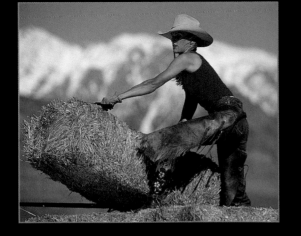

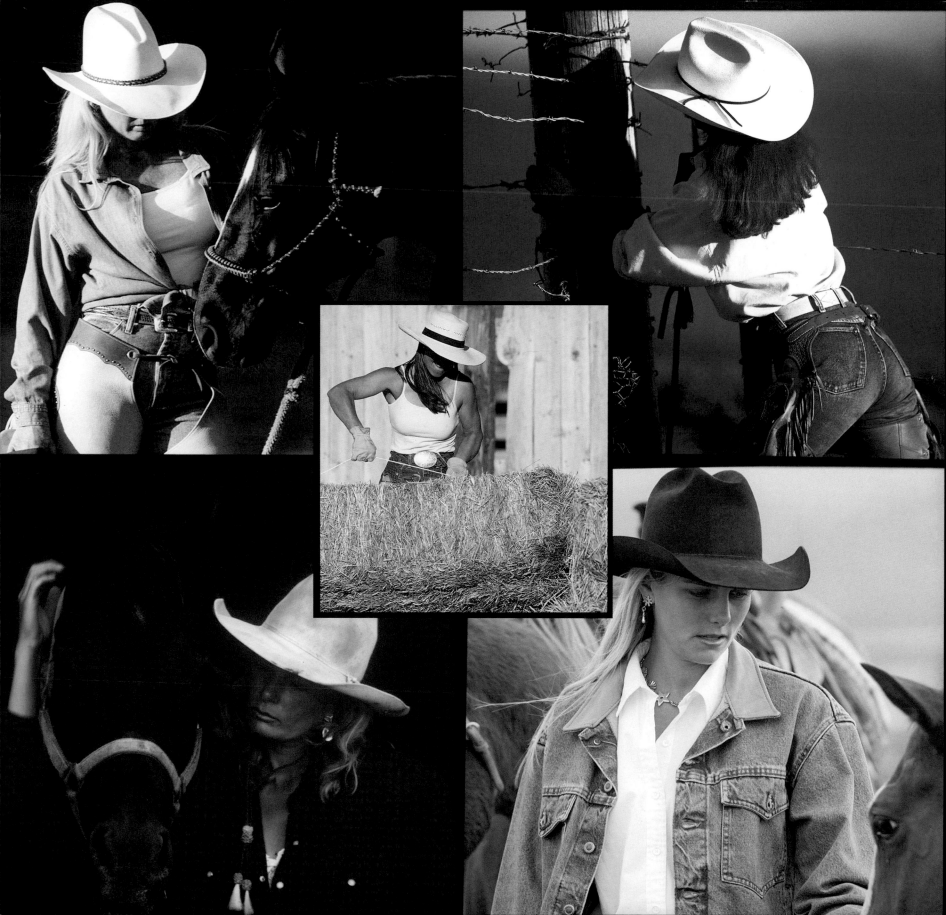

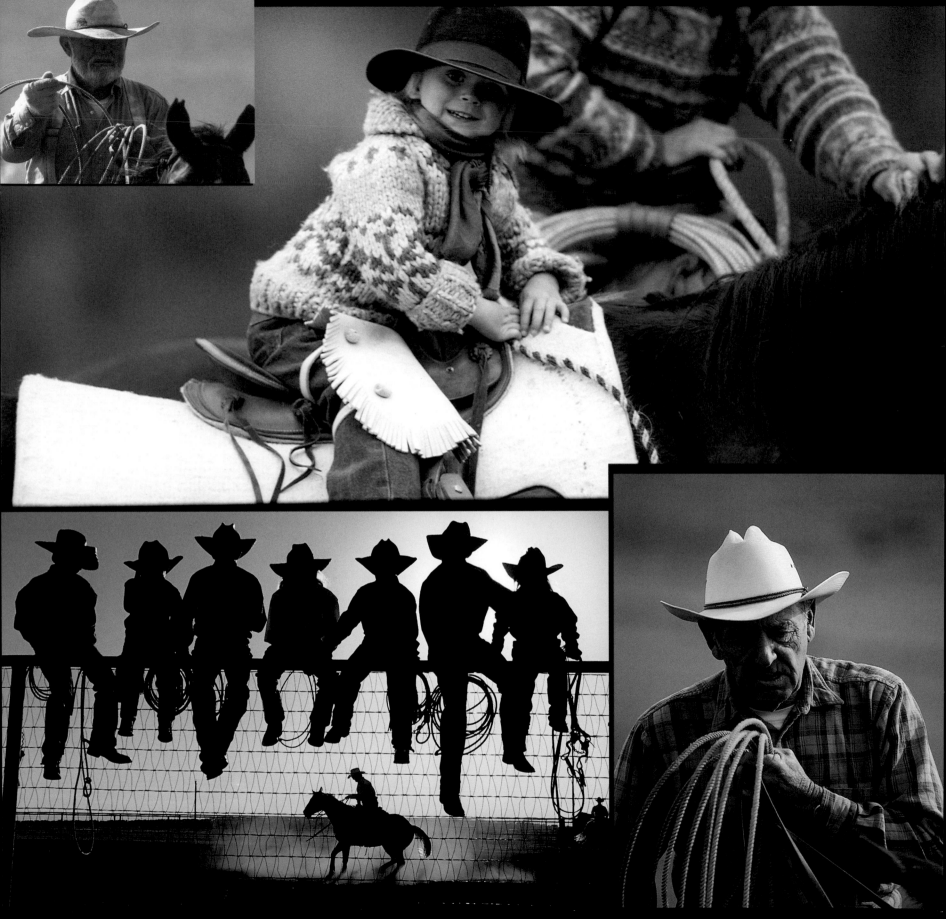

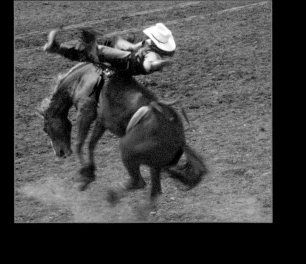

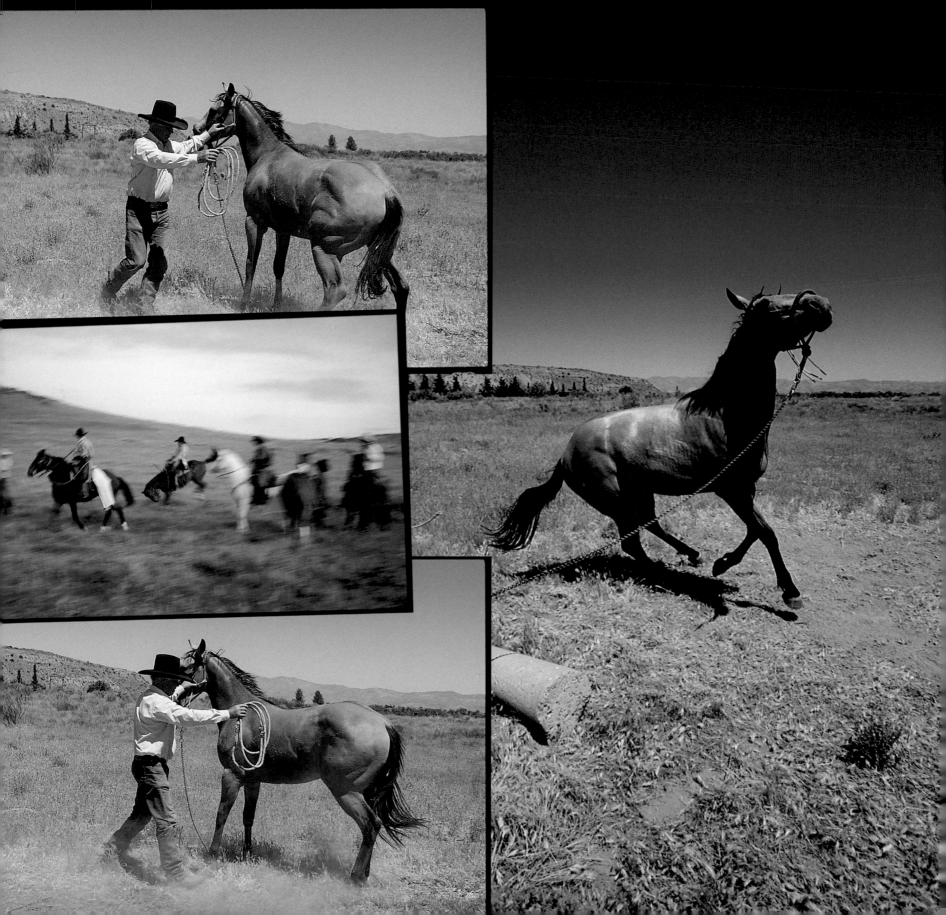

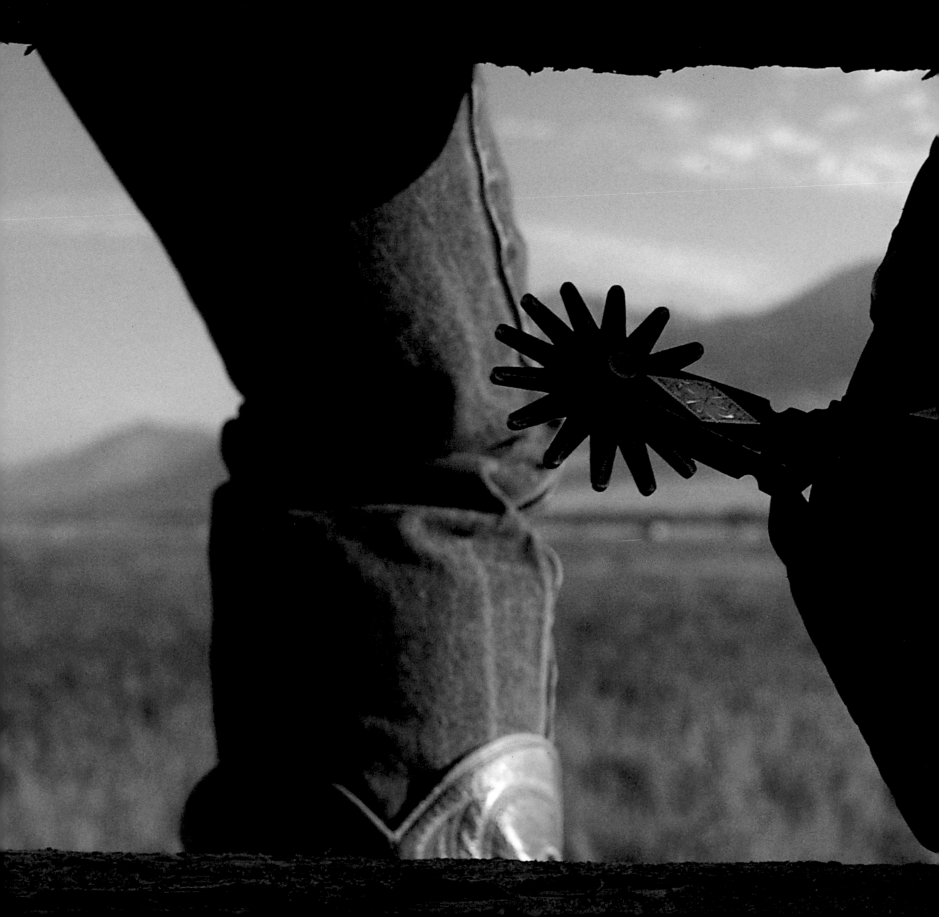

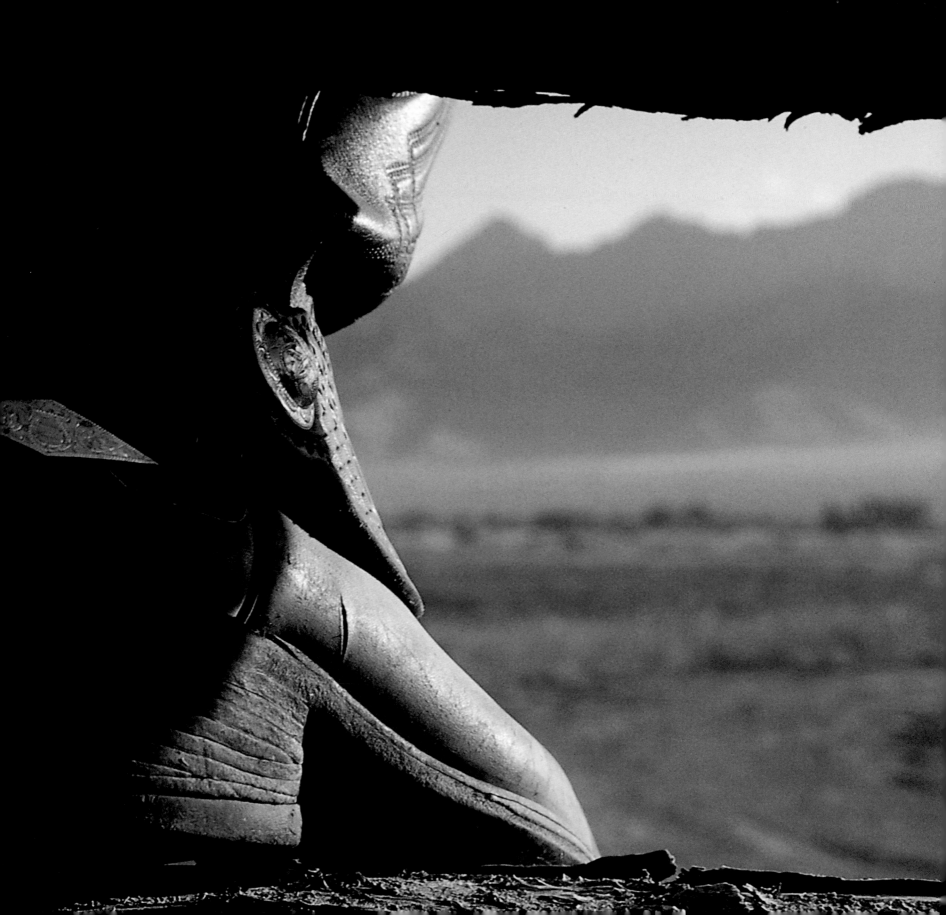

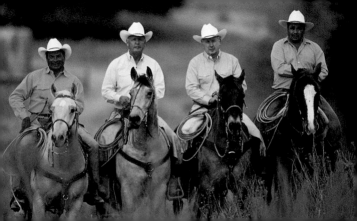

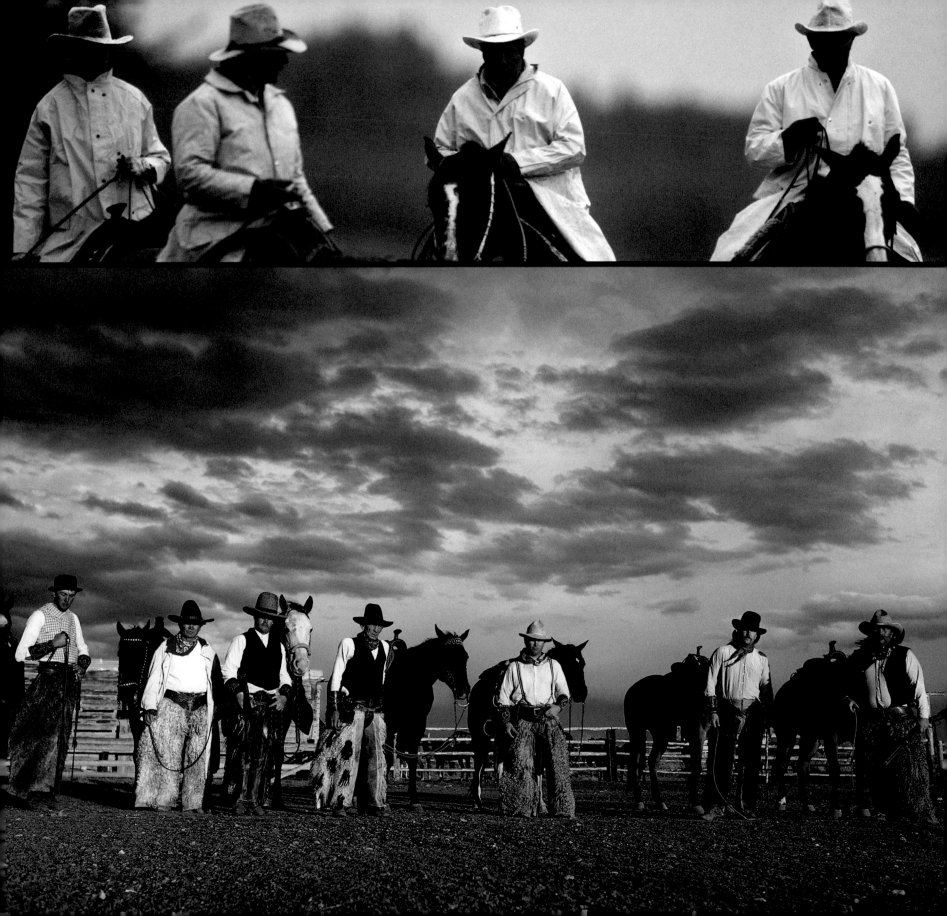

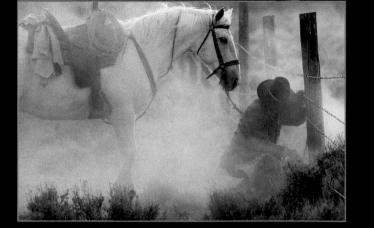

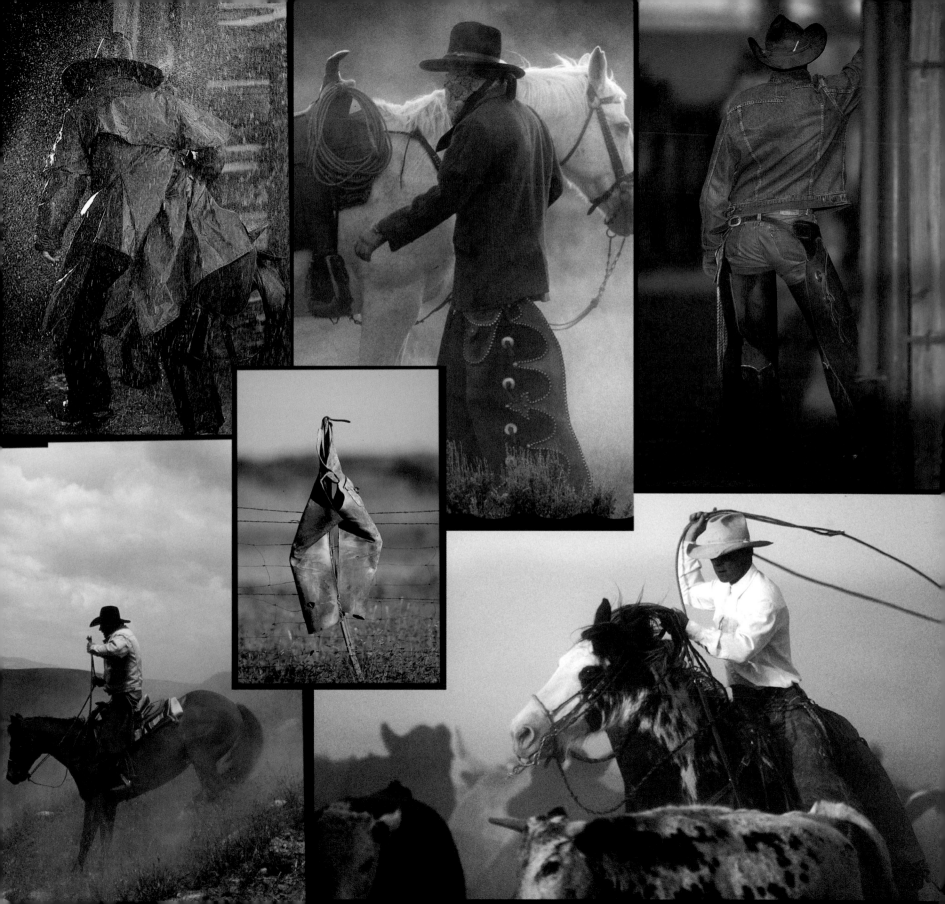

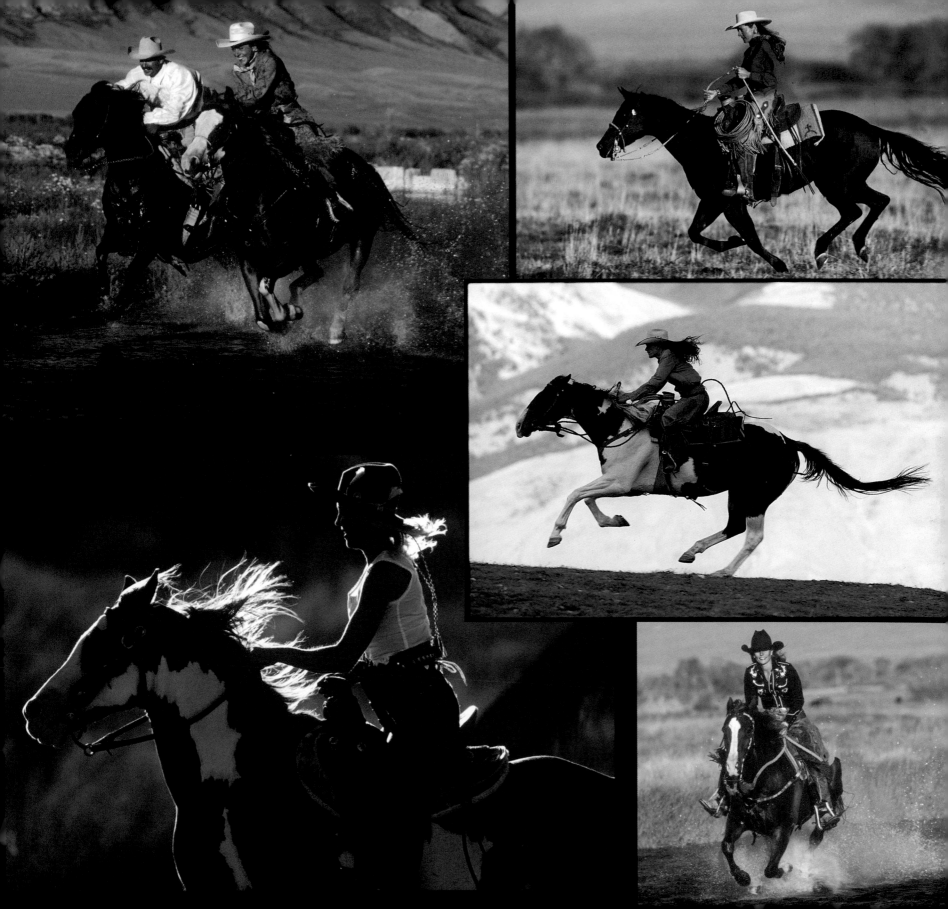

Cowboy Wisdom:

WHEN YOUR COWGIRL
PLAYIN' HARD TO GET,
IT'S GOOD TO HAVE A FAST HORSE.

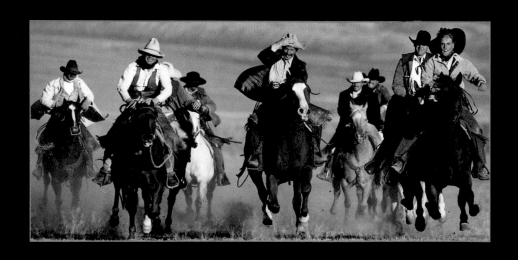

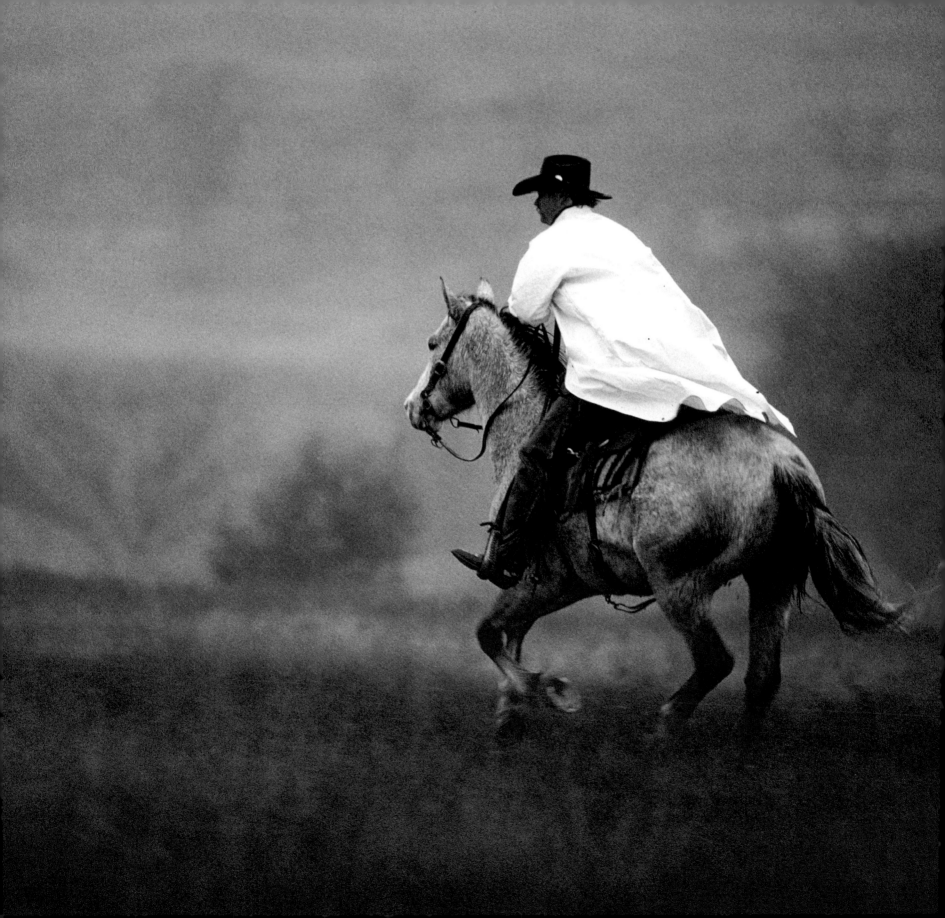

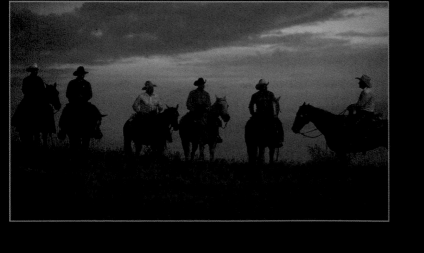

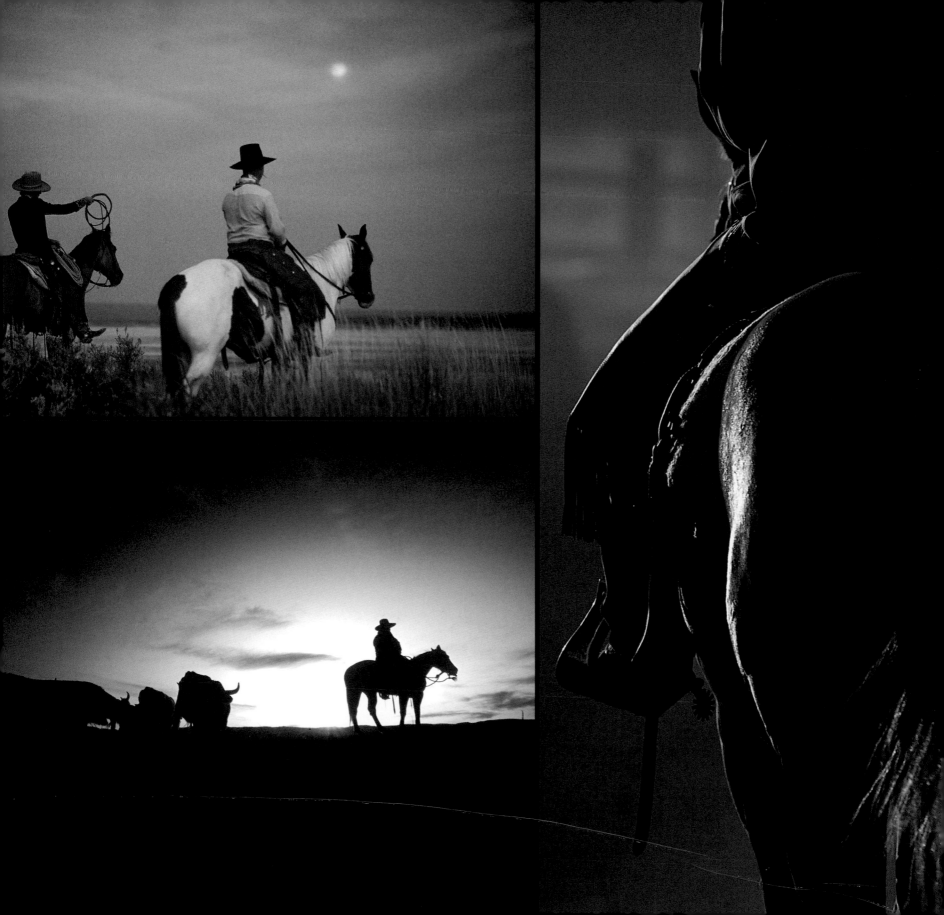

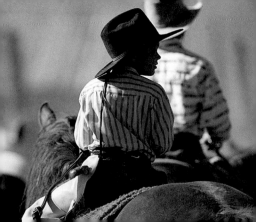

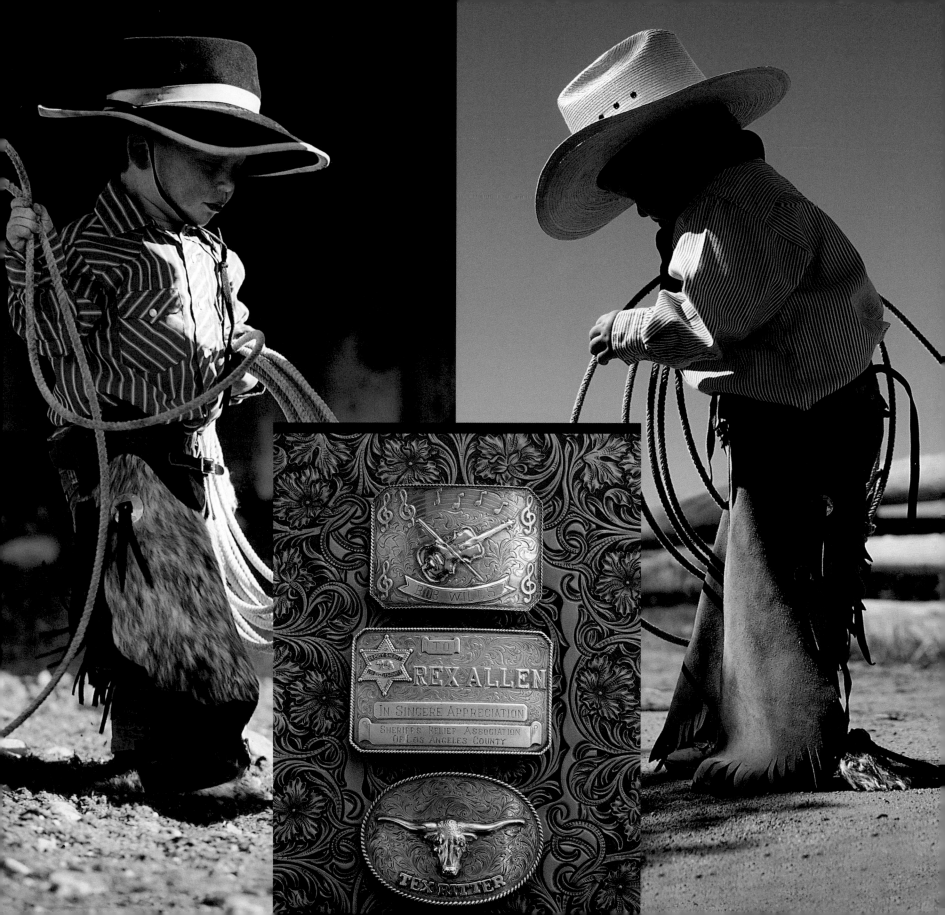

IF YOUR HORSE DON'T WANNA GO THERE
THEN YOU DON'T EITHER.

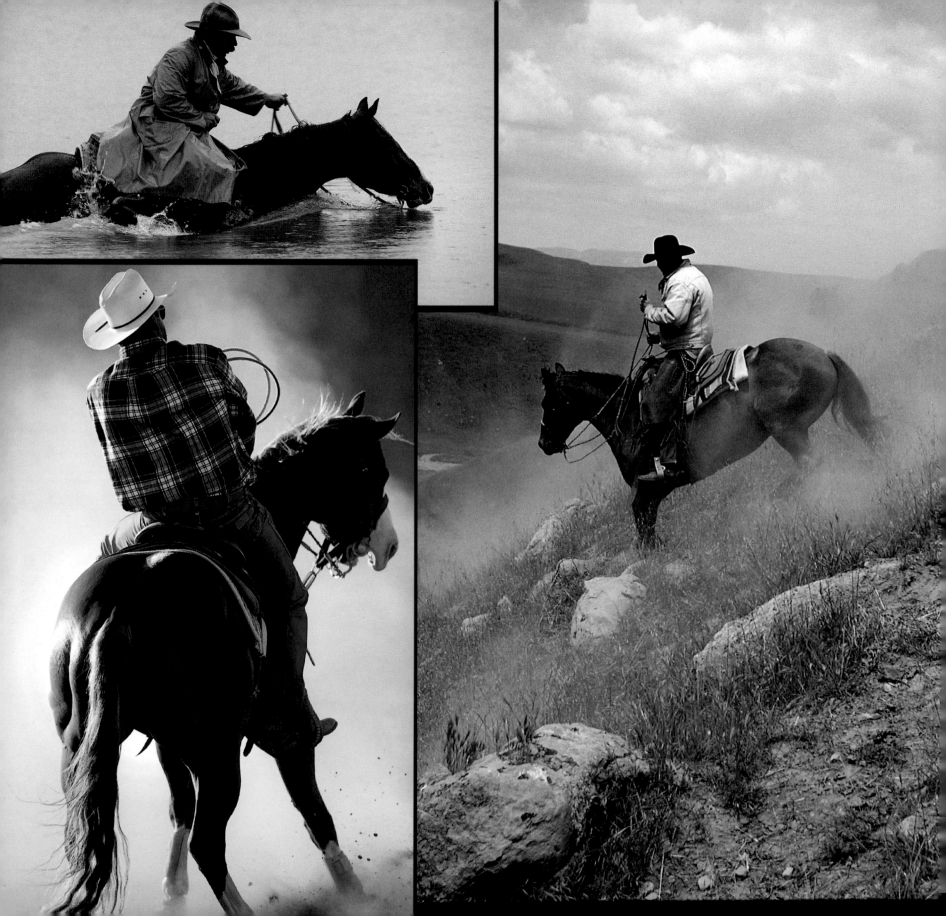

Cowboy Wisdom:

BEFORE YOU CRITICIZE SOMEONE,
WALK A MILE IN THEIR BOOTS.

THAT WAY YOU'RE A MILE AWAY FROM 'EM
AND YOU HAVE THEIR BOOTS TOO.

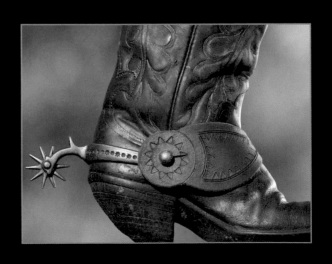

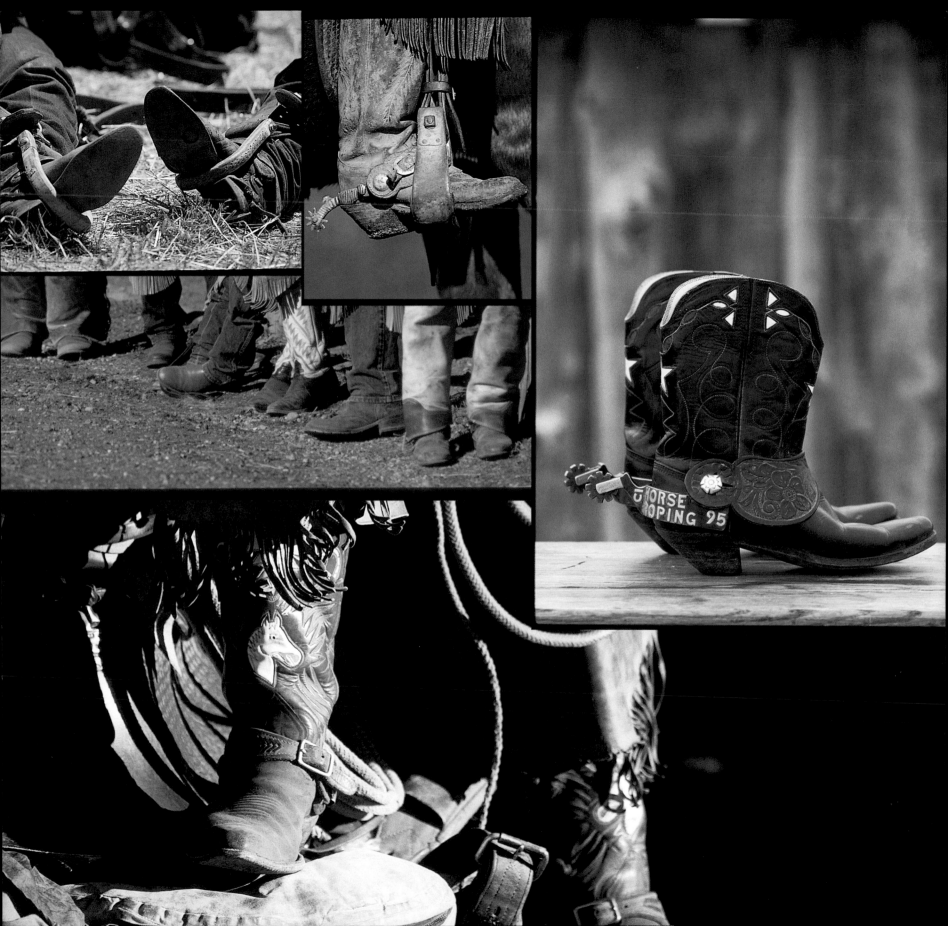

Cowboy Wisdom:

GOOD JUDGEMENT COMES FROM
EXPERIENCE.

MOST OF WHICH COMES FROM
BAD EXPERIENCES WITH
BULLS
AND WOMEN.

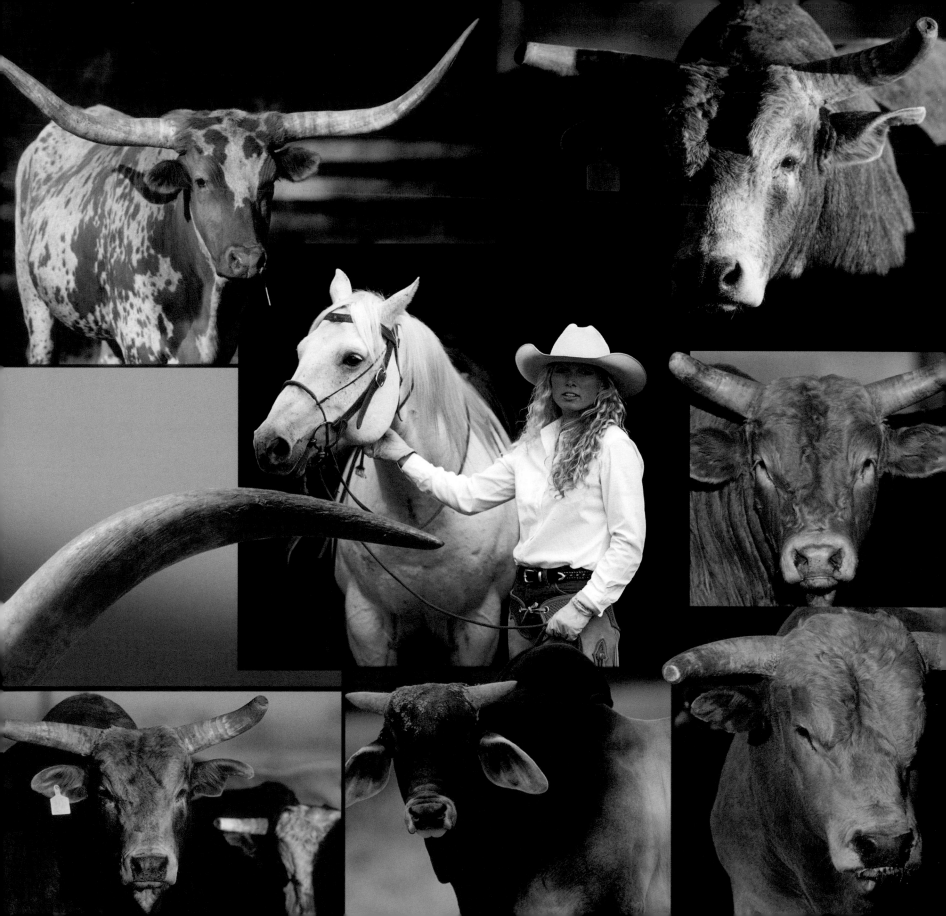

Cowboy Wisdom:

IF YOU REACH THE END OF YOUR ROPE
GO TO THE KNOT AND HANG ON.

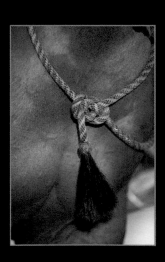

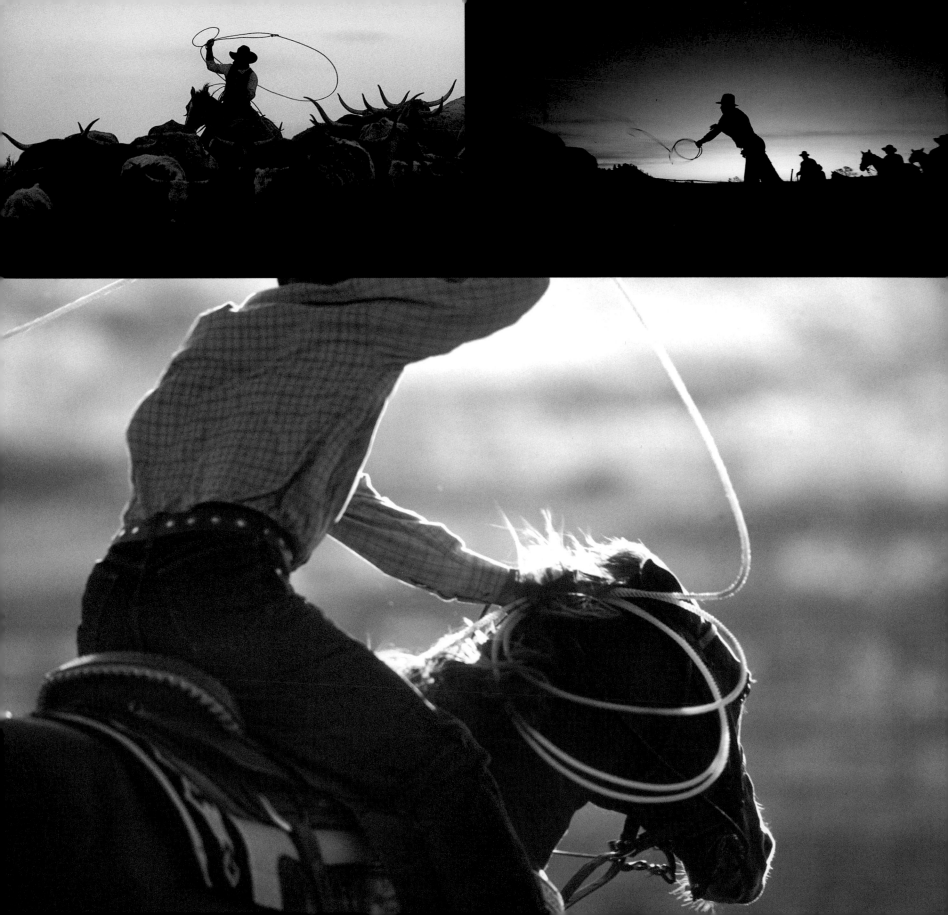

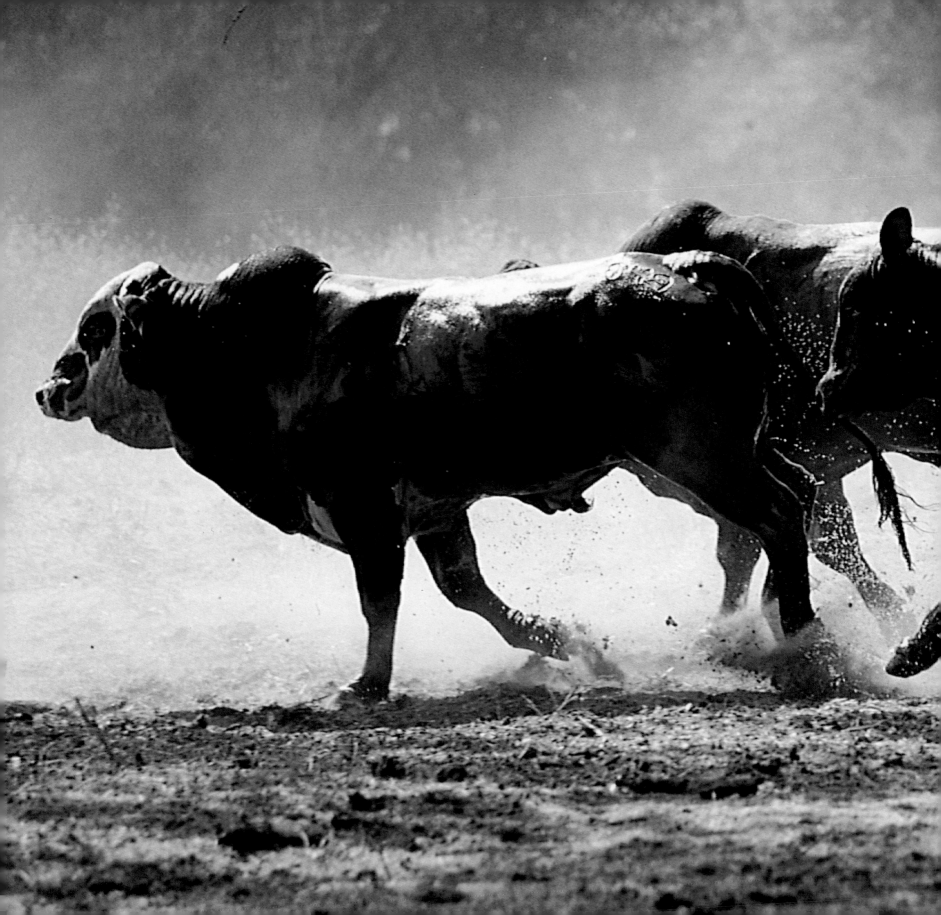

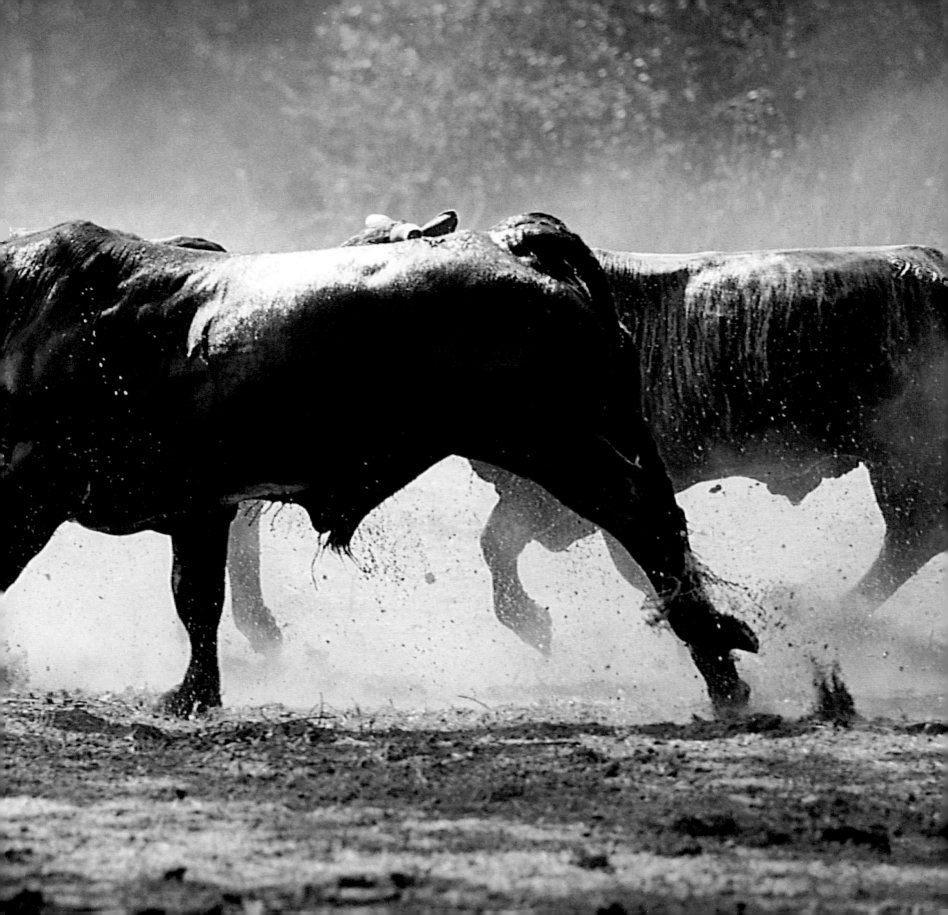

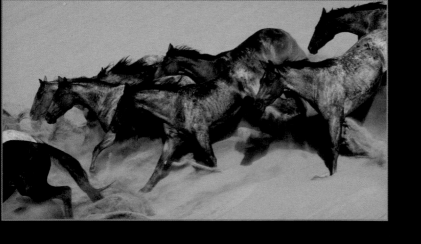

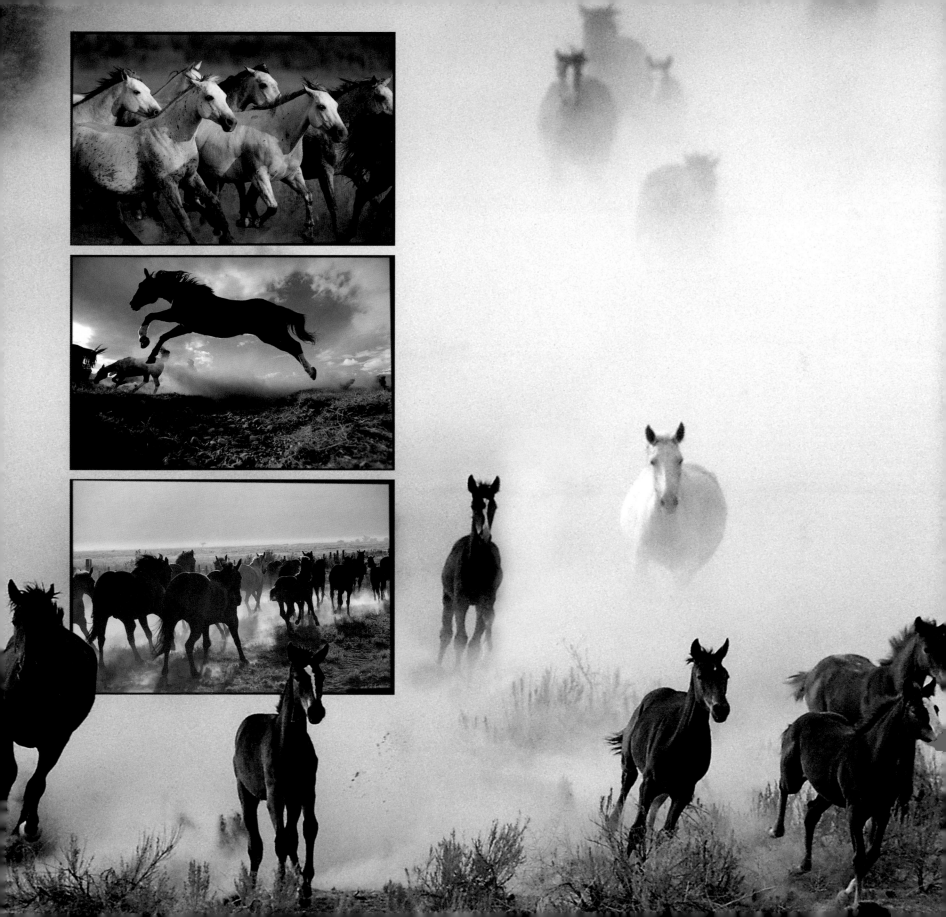

Cowboy Wisdom:

CAREFUL IS A NAKED MAN
CLIMBING A BARBED WIRE FENCE.

'COURSE IF YOU'RE A NAKED MAN
CLIMBING A BARBED WIRE FENCE,
IT'S PROBABLY A LITTLE TOO LATE FOR CAREFUL.

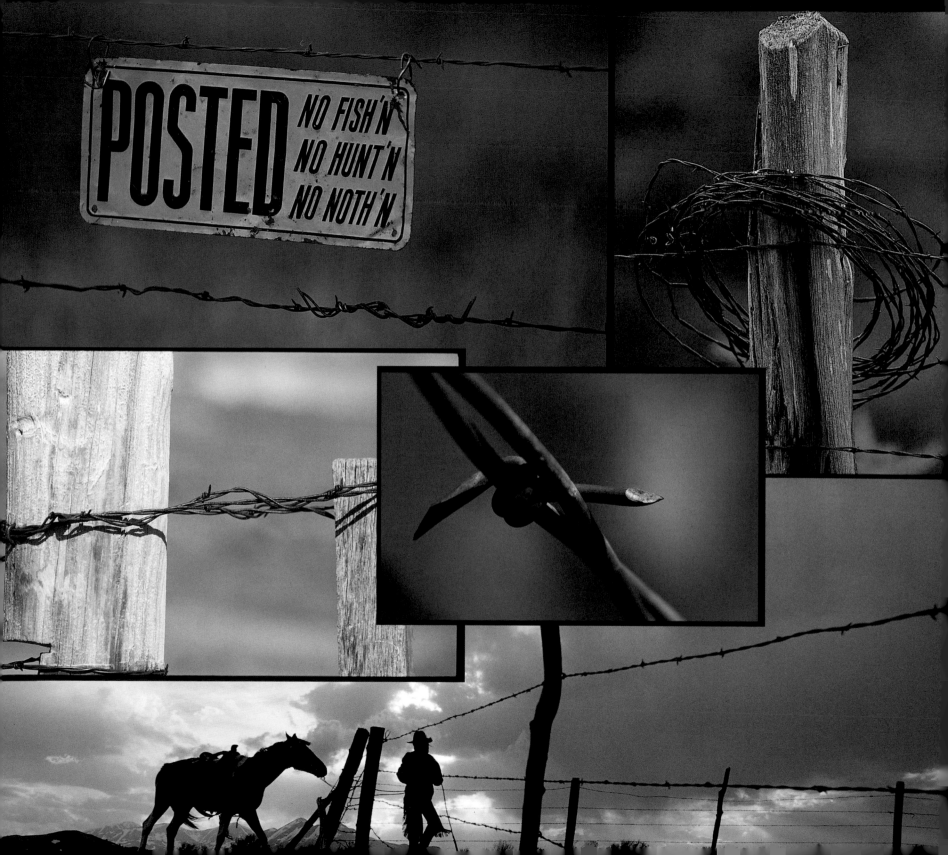

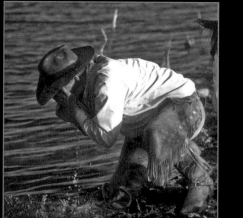

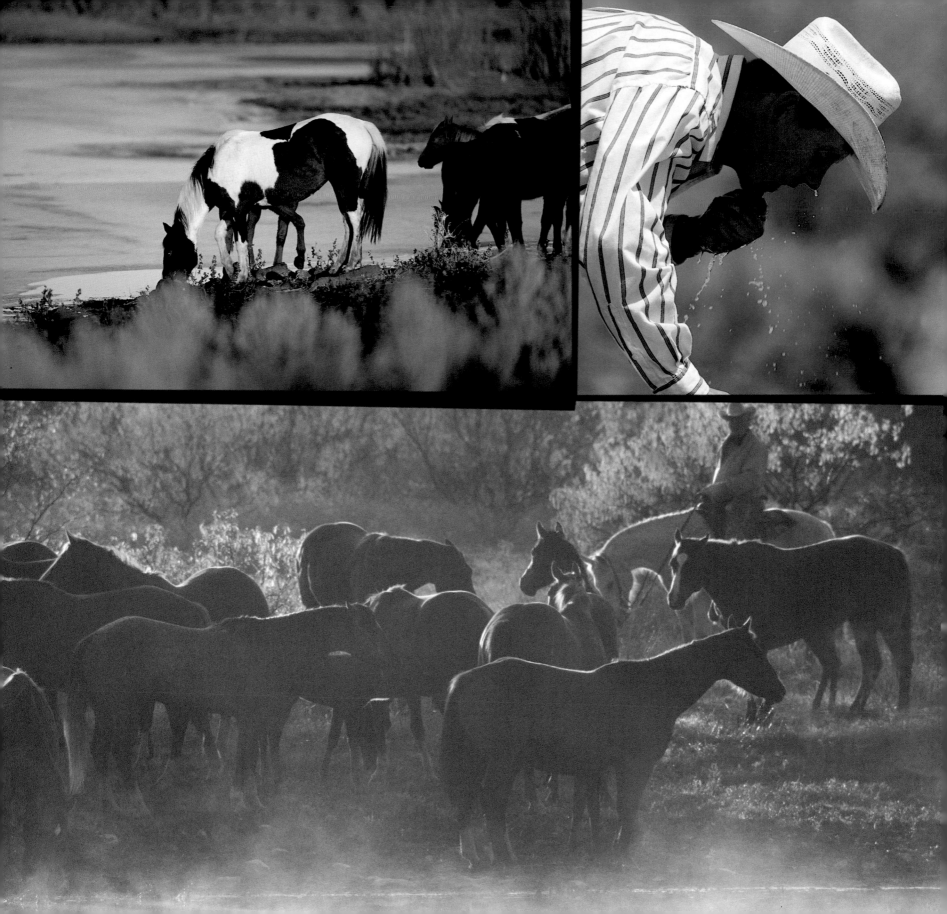

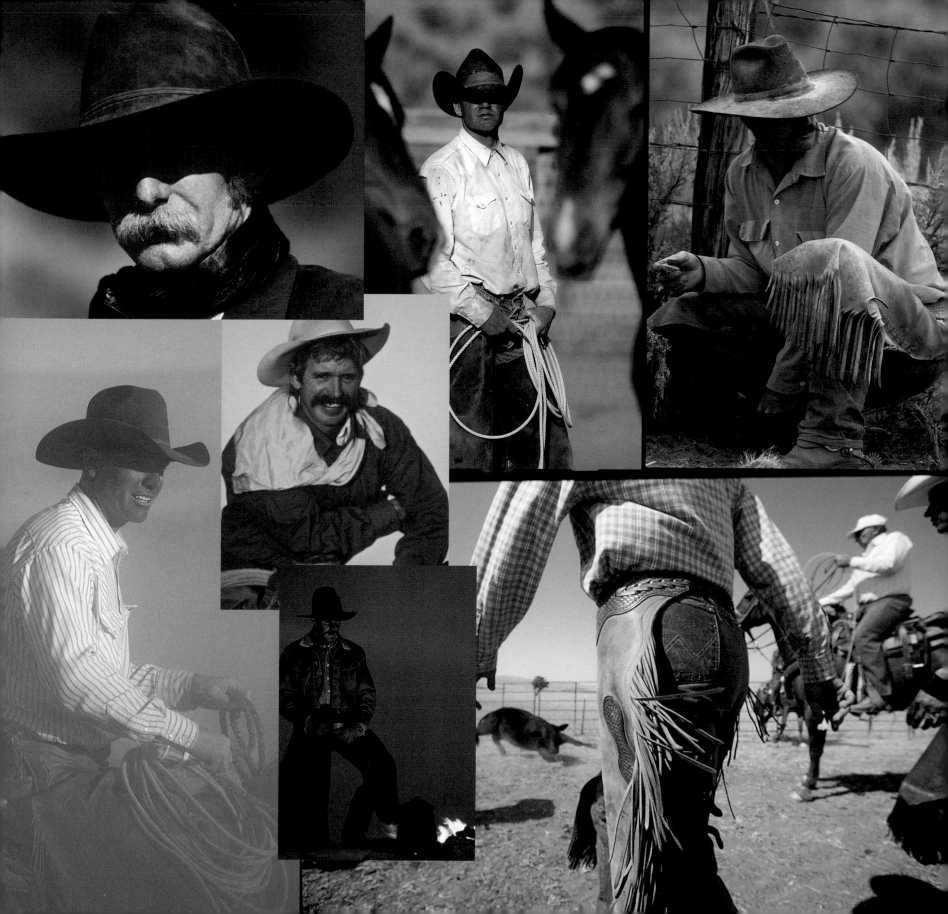

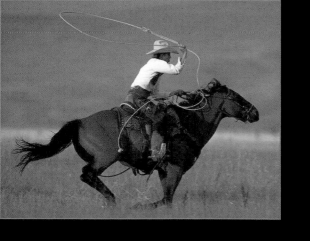

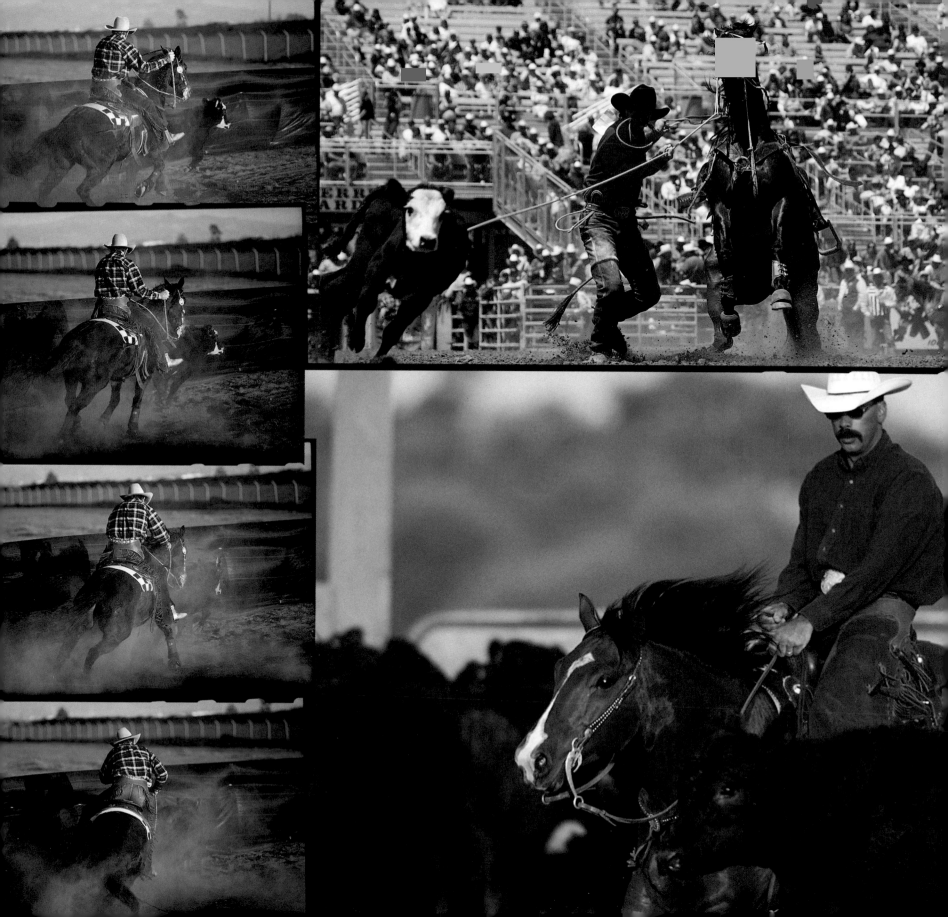

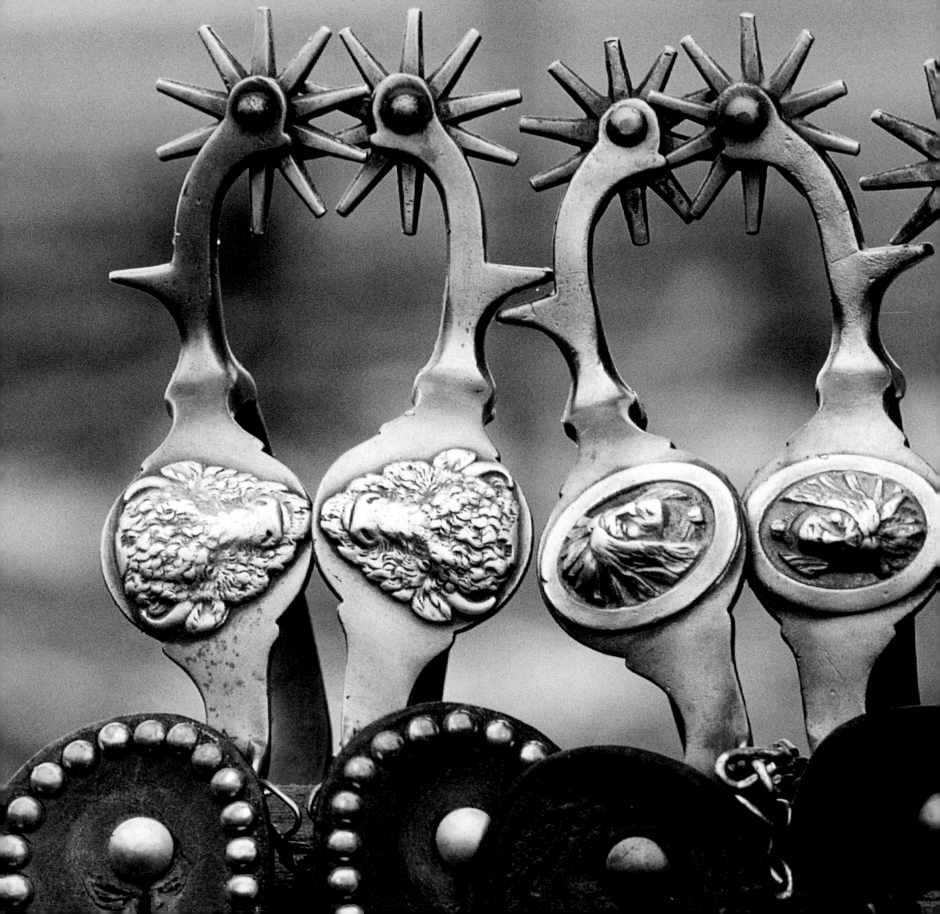

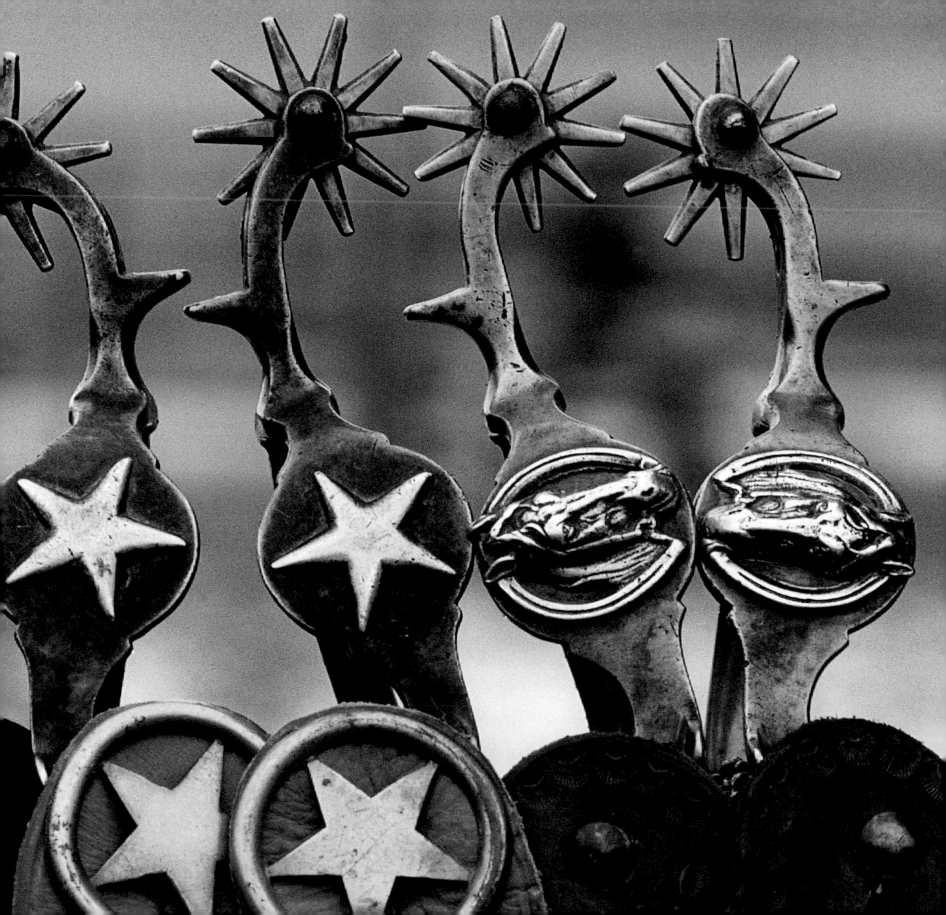

Cowboy Wisdom:

THE BEST WAY TO GET RID OF CHAPPED LIPS
IS TO SPREAD COW MANURE ON 'EM.

IT DON'T ADD MOISTURE BUT IT WILL
KEEP YOU FROM LICKIN' 'EM.

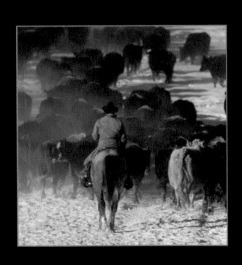

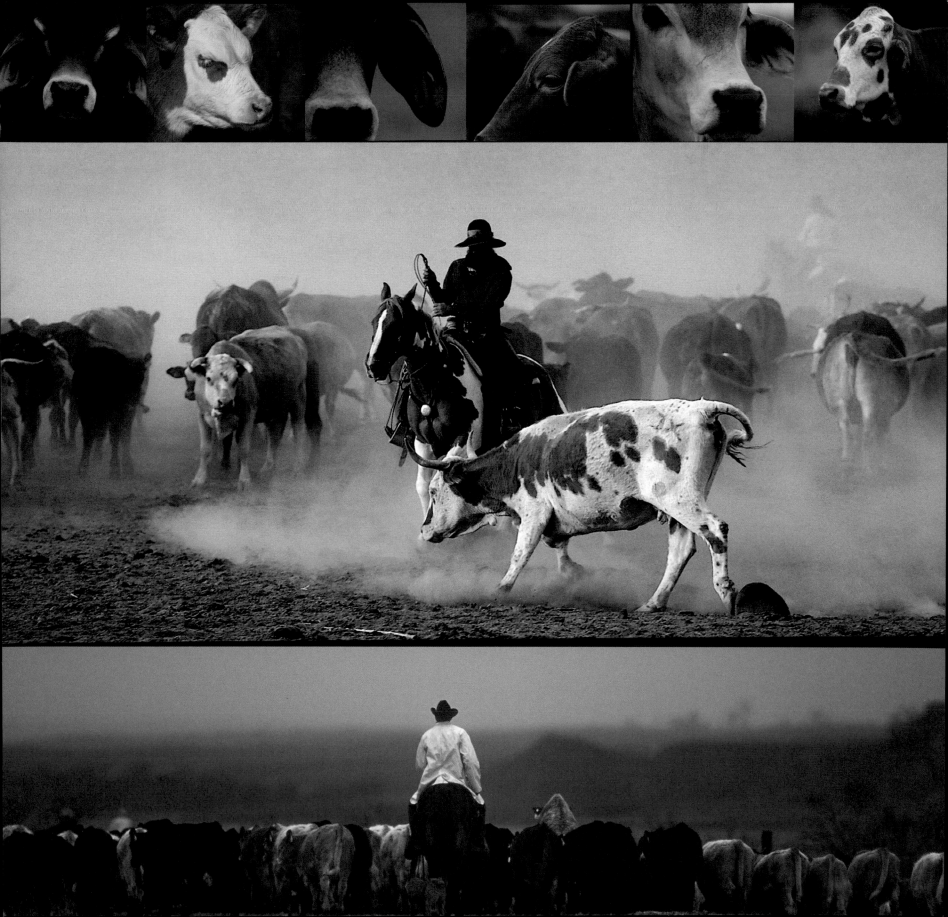

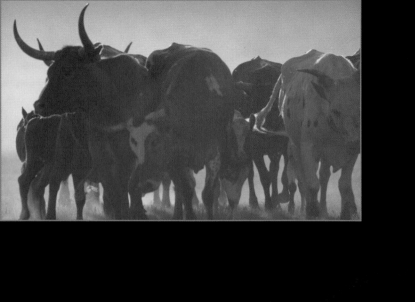

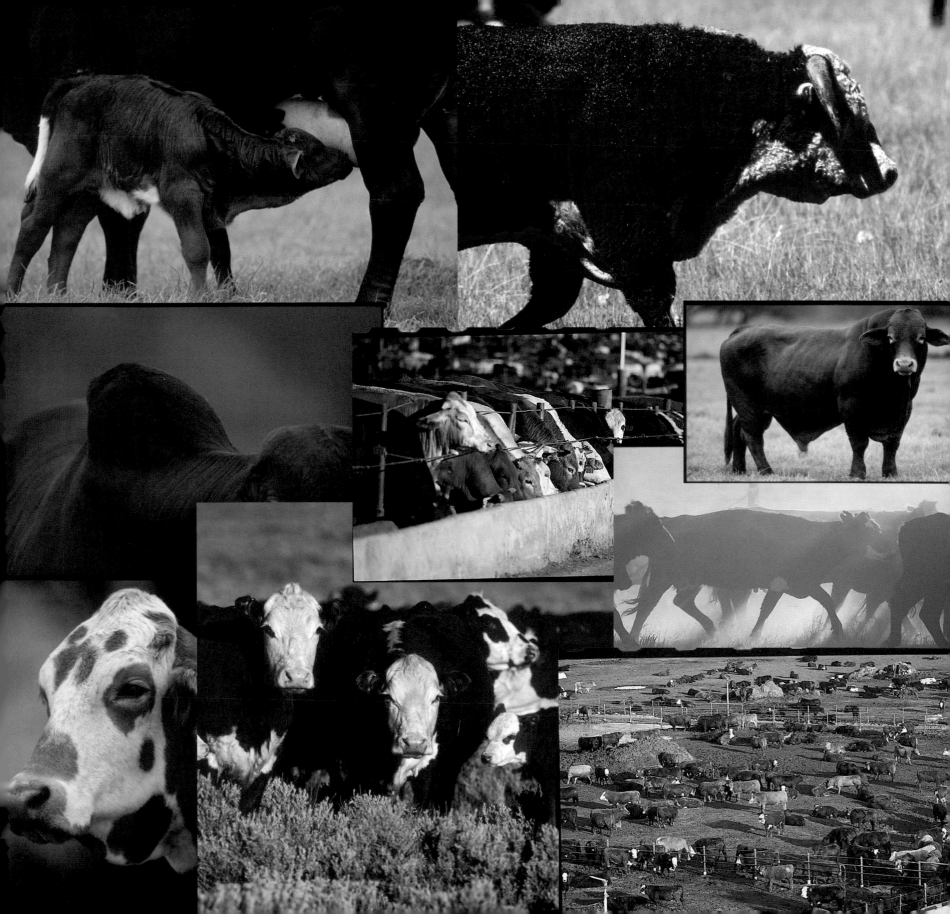

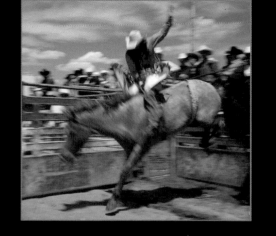

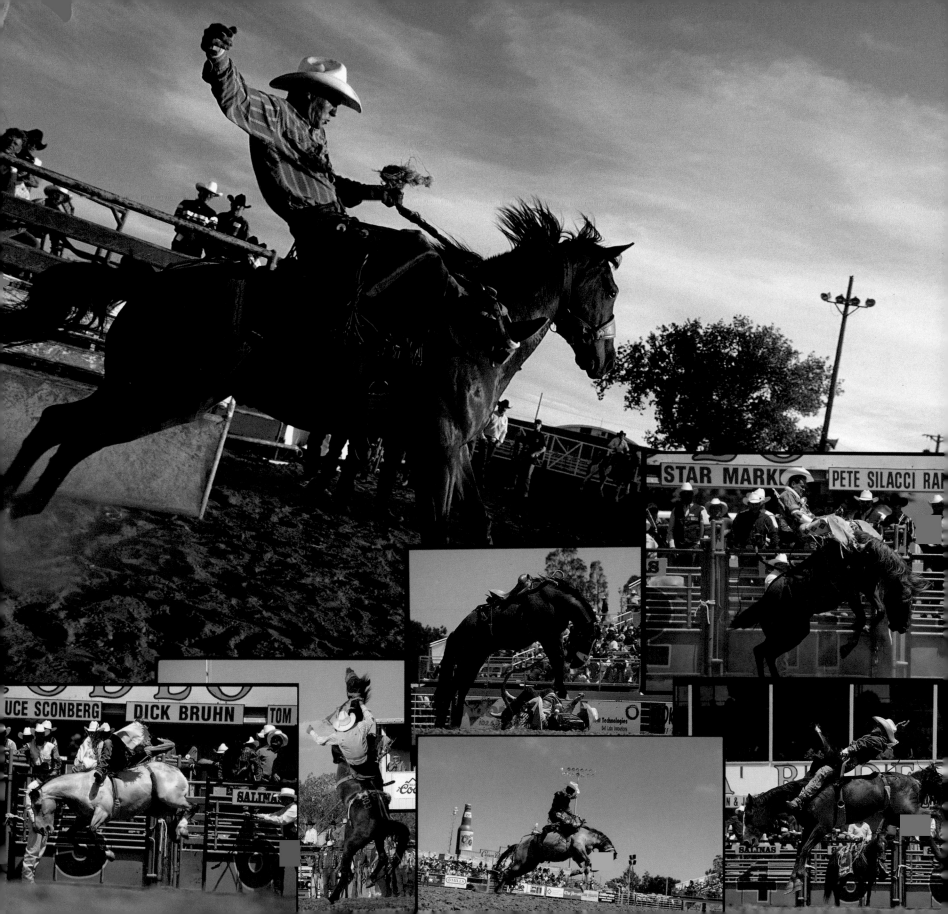

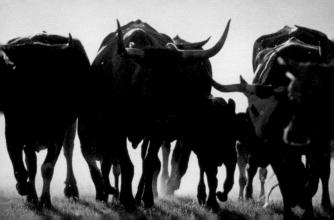

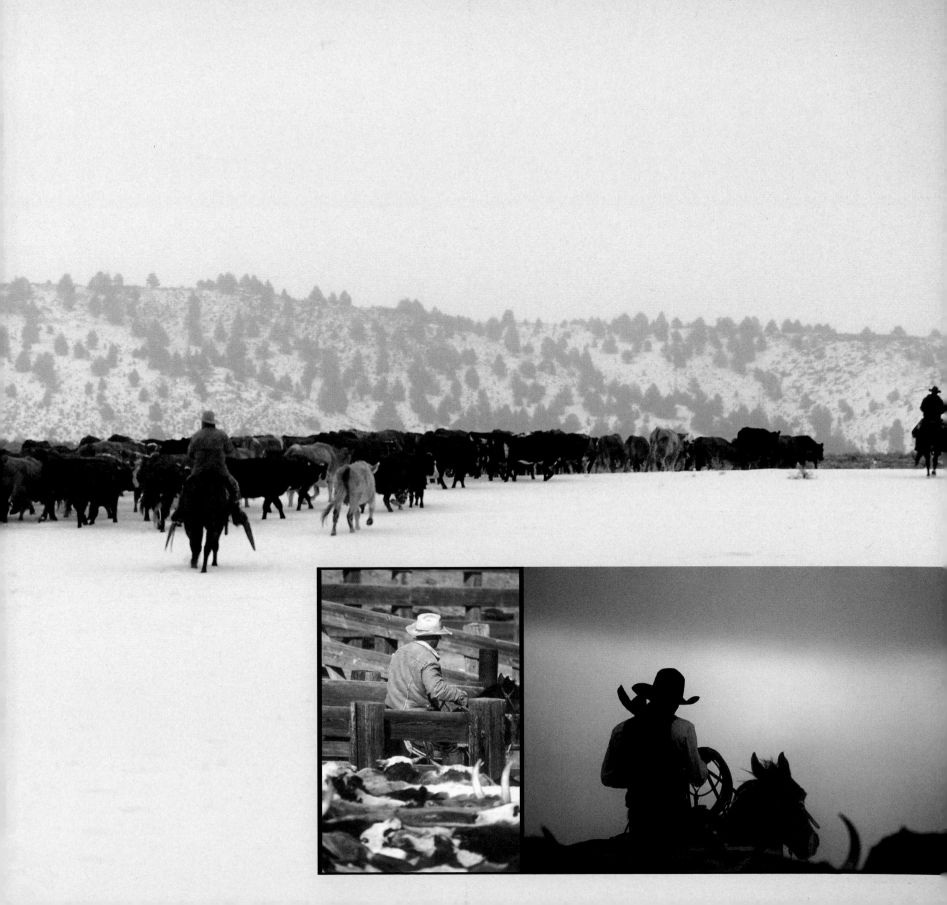

ACKNOWLEDGEMENTS

PHOTOGRAPHER

DAVID STOECKLEIN, STOECKLEIN PHOTOGRAPHY & PUBLISHING

In the companion book to this one, *Cowboy Ethics,* author James P. Owens writes, "From the first moment I saw David's images of the West, I was stunned at how perfectly they capture the cowboy spirit ~ the nobility of the men, their love of their way of life, and the majesty of their surroundings. His artistry and his dedication to "the cowboy way" have been an inspiration. I am honored to have his work appear with mine."

I could not agree more with that eloquent statement and it bears repeating here. I would only add that since first meeting David on a week-long photoshoot for Wrangler, I knew then, as I know now, that the man behind the camera was as much a cowboy as the professional rodeo cowboys we were shooting that week. He lives his life by the same code and wisdom written about in this book. It was my pleasure to have been a part of this endeavor with him.

MY INSPIRATION

WRANGLER JEANSWEAR

Any book I ever write regarding the Western lifestyle must include an acknowledgement to the many people at Wrangler who have allowed me to experience this American lifestyle firsthand. Western life is alive and vibrant in large part due to brands like Wrangler that take such pride in supporting it. There are too many people to mention by name, so I will not try. Suffice it to say, thanks to all of you.

MARKETING DIRECTOR

NANCY RYAN, STOECKLEIN PHOTOGRAPHY & PUBLISHING

This book could not have happened without Nancy. She quickly responded to my many requests and kept me constantly supplied with the beautiful images that brought this book to life.